PIONEERING
WOMEN *of*
GLACIER NATIONAL PARK

DAVID R. BUTLER

AMERICA
THROUGH TIME®
ADDING COLOR TO AMERICAN HISTORY

America Through Time is an imprint of Fonthill Media LLC
www.through-time.com
office@through-time.com

Published by Arcadia Publishing by arrangement with Fonthill Media LLC
For all general information, please contact Arcadia Publishing:
Telephone: 843-853-2070
Fax: 843-853-0044
E-mail: sales@arcadiapublishing.com
For customer service and orders:
Toll-Free 1-888-313-2665

www.arcadiapublishing.com

First published 2023

Copyright © David R. Butler 2023

ISBN 978-1-63499-454-5

Typeset in 10.5pt on13pt Sabon
Printed and bound in England

Acknowledgments

Historic photos of, and about, early pioneering women of Glacier National Park featured in this book come from a wide range of sources. I have tried to be as specific as possible with the photo attributions and hope that I have done so accurately; any mistakes are mine alone. Photo attribution abbreviations include CMRM, Charles M. Russell Museum, Great Falls; GNP, Glacier National Park; GLAC, Glacier National Park collection; GNR, Great Northern Railway; MHS, Montana Historical Society; MNHS, Minnesota Historical Society; NPS, National Park Service; OHSL, Oregon Historical Society Library; TU, Gilcrease Museum, University of Tulsa; UMT, University of Montana; and USGS, U.S. Geological Survey.

My thanks are extended to the good folks at America Through Time and its parent company Fonthill Media, the editorial and publishing team that worked with me in creating this book, especially Alan Sutton, Kena Longabaugh Smith, and Jamie Hardwick. It is a pleasure to work with such professionals.

Thanks and appreciation to friends and family members who have accompanied me on hikes, drives, and fieldwork in and around the park, many such activities resulting in the more modern photographs appearing in this book. Thanks also among that group to Dr. Lynn M. Resler for introducing me to Dorothy Pilley's book *Climbing Days*.

Thanks also to the kind young woman I spoke with at Kalispell's Hockaday Museum of Art. After weeks of fruitless searching by me, she hooked me up with a copy of the Hockaday Museum's book *A Timeless Legacy: Women Artists of Glacier National Park* in under five minutes.

Finally, thanks as always to my family. They accompanied me on many visits to Glacier National Park and continue to be willing to travel with me to the park whenever possible.

Contents

Introduction

Glacier National Park, Montana, was established in May 1910 by an Act of Congress and presidential signature. Prior to that, the area of what is now the park was afforded some protection by the establishment of the Flathead Forest Preserve in June 1896, westward of the Blackfeet Indian Reservation. Nonetheless, forest preserve status (roughly analogous to today's National Forest concept) offered less protection than the future National Park status the area would achieve, and thus was open to both mineral exploration throughout as well as homesteading (and some squatters) on the western side of the preserve; limited homesteading on the eastern side occurred only south of the boundary of the Blackfeet Reservation. Each of the two distinctly different sides of the park therefore underwent different settlement landscape development than the other side. These settlement patterns, combined with the milder and moister climate on the west side of the park, contrasted with the cold, blustery, and drier east side of the park resulted in distinctly different landscape signatures and histories.

Women were few in number in the frontier of Euro-American northwestern Montana. On the east side of the mountains, the Blackfeet Indian Reservation bounds what is now the eastern border of the park. Little is known about the number of indigenous women in the area on the reservation at that time. Euro-American homesteading and mineral exploration were at a relative minimum due to the reservation presence and status, although oil and mineral (especially copper) explorations did occur beyond the western boundary of the reservation in the Swiftcurrent valley after that area was ceded to the U.S. government by the Blackfeet in 1895. Native Americans mixed with European settlers in communities along the border between the reservation and what would become Glacier National Park, in the villages of Midvale (later to become Glacier Park and eventually East Glacier), St. Mary, and Babb. Homesteading on the east side was limited primarily to a small strip of land running southwest of Glacier Park to the Continental Divide at Summit. Mining communities sprang up in

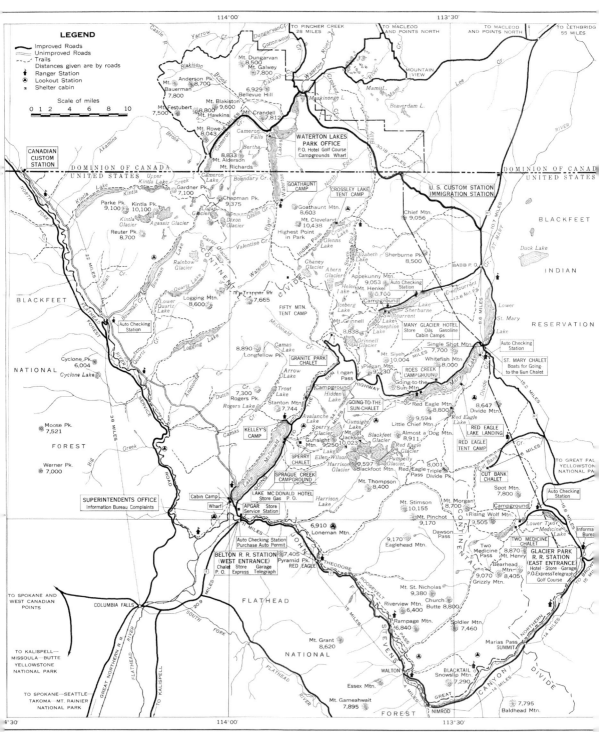

MAP OF WATERTON-GLACIER INTERNATIONAL PEACE PARK

Map of Glacier National Park, 1937. (*NPS*)

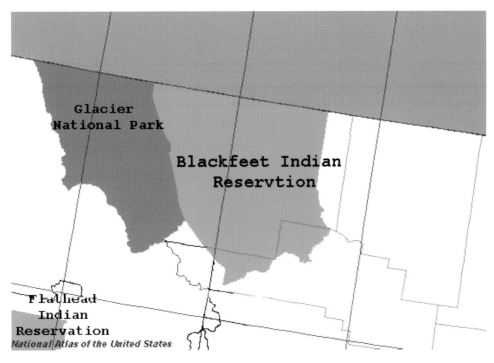

Map showing the location of Glacier National Park relative to the Blackfeet Nation/Indian Reservation to the east. Canada is the gray area to the north. (*National Atlas of the United States*)

St. Mary and short-lived Altyn in the Swiftcurrent valley. With the exception of miners, Euro-American shopkeepers and their families in those towns were some of the few non-Native people there in the very late nineteenth and early twentieth century.

The west side of what would become Glacier Park illustrated a very different pattern of exploration and settlement by Euro-Americans. There, forest rangers based out of Lake McDonald regularly patrolled the area west of the Continental Divide. North of Lake McDonald along the eastern (and western, but that is outside today's Glacier Park boundary) side of the North Fork of the Flathead River, homesteads were established in grassy meadows. Thirty-six of the forty-eight homestead patents issued within the park prior to the creation of the park in 1910 were in this area. South of Lake McDonald, along the Middle Fork of the Flathead, only a few homesteads were developed east of the river in what is now Glacier Park, but those few did play important roles in the development of the area. The presence of homesteads meant that more families, and therefore more women, settled on the west, especially northwest, side of the park than occurred on the east side. Women continued to be few in number nonetheless, especially for members of the ranger workforce of the Flathead Forest Preserve/new Glacier National Park, which at that time was exclusively a male domain.[1]

For the purpose of this book, I need to define the timeframe that this book covers and what I mean by "pioneering women". The timeframe in question

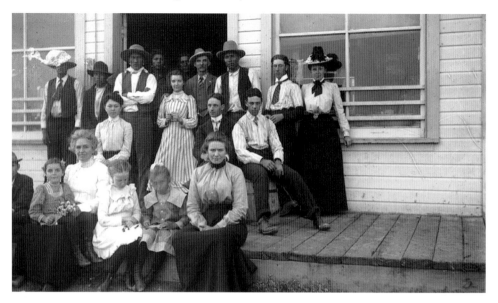

Group of men, women, and children pictured sitting and standing on a store porch, 1901, in or near Glacier National Park. The store could be an early, unaltered version of Thronson's General Store in Babb, especially given the large number of Native American men in the photograph and the original elevated "boardwalk" entrance along the front of the store. Well into the 1990s, Thronson's still retained that boardwalk sidewalk front. The photo may also have been taken in Browning, adjacent to Glacier Park. (*Photographer unknown, UMT 013370*)

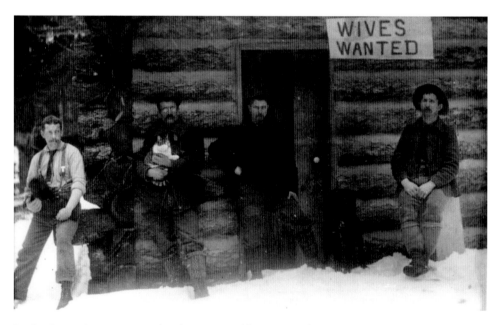

In the Forest Reserve around Lake McDonald at Apgar, four men advertise for wives, *circa* 1901. *From left to right*: Bill Daucks, Frank Geduhn (Forest Service ranger before Glacier National Park was established in 1910), Esli Apgar (in doorway of cabin), and (Harvey) Dimon Apgar. Geduhn holds a cat, and a dog sits between Esli and Dimon Apgar. (*Photographer Unknown, GNP Archives HPF 9871*)

is from pre-park days up to roughly 1940, *i.e.* prior to park creation and the first thirty years of Glacier National Park. Pioneering women include a wide range of women doing things atypical for women during this time period. These activities range from Blackfeet and other Native American women carrying out extraordinary feats, to women homesteaders, wives of early park rangers, early women writers visiting the park, early women artists and influential artists' wives, and influential pioneering outdoorswomen. All were engaged in activities outside the norm of expectations for women in this time period, and all helped advance the cause of putting female faces and names into the history of a park which, up to this point, have been largely ignored or anonymous.

1

Native American Pioneering Women

Due to the oral, non-written, tradition of the Native Americans in the area that became Glacier National Park, little is known about individual indigenous women in the pre-park and early park days. What is known is that Native people utilized parts of Glacier National Park on both sides of the Continental Divide, including the east-side dwelling Blackfeet (specifically the South Piegan or Pikunni (or Pikuni) tribe of the Blackfoot Confederacy) and the west-side dwelling Flathead Kootenai of the Confederated Salish and Kootenai Nation. Both groups occasionally crossed over the Continental Divide on forays into the other's territory; sometimes, these excursions were peaceful, accomplished under a pipe of peace, and sometimes, there was warfare from raiding/warring parties. What both groups had in common was a lack of a written tradition hampering recognition of individual significant female accomplishments.[1]

Sacagawea

The first Native American woman to discuss associated with Glacier Park was neither a member of the Blackfeet nor the Kootenai tribe. Born near present-day Salmon, Idaho, and Shoshoni in origin, Sacagawea was taken by the Hidatsa tribe of the Mandan-Hidatsa-Arikara Nation to live in a Hidatsa village near present-day Mandan, North Dakota. There she became the child wife (at approximately thirteen years of age) of a Quebecois trapper named Toussaint Charbonneau. In November 1804, the Lewis and Clark expedition built winter quarters near the village and hired Charbonneau and his pregnant wife Sacagawea as guides and interpreters for the trip westward to the Rockies and on to the west coast.

Sacagawea gave birth a few months before the expedition left for points westward. She served as interpreter in the country south of Glacier and into

Idaho, and helped locate mountain passes. In addition, the sheer presence of a Native American woman with her child helped to illustrate to the tribes through whose land the expedition passed that they were a peaceful group. The expedition never entered what is now Glacier National Park. Members of the expedition did, however, see Glacier's peaks from a point at Camp Disappointment, about 12 miles east of Browning, Montana, today's headquarters of the Blackfeet Reservation.

Sacagawea's role in the expedition is honored with several statues throughout the west, and most notably perhaps she and her child were honored with a likeness (no photographs of her actually exist) on the $1 coin first issued by the U.S. Mint in the year 2000. Her name, Sacagawea, translates roughly as "Bird Woman," and Bird Woman Falls in Glacier Park, a prominent landmark on the west side of Going-to-the-Sun Road, also may honor her role in the region's history, although controversy exists as to whether the falls are actually named after her or rather after the wife of a local Blackfeet chief.[2, 3, 4]

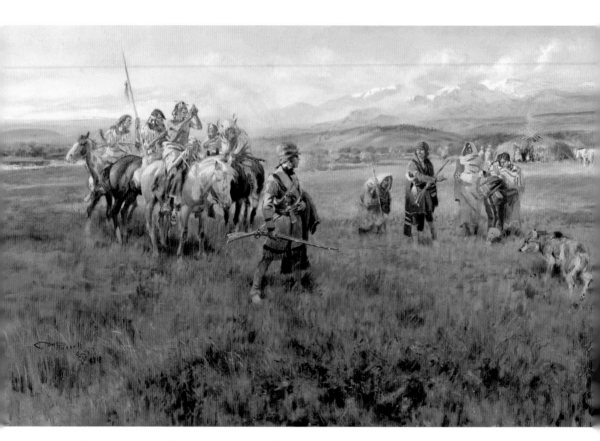

Charles M. Russell painting (1918) of the Lewis and Clark Expedition, led by Sacagawea, arriving at a Shoshoni/Shoshone camp. Sacagawea is embraced by a long-lost family member. (*Thomas Gilcrease Foundation, 1955, TU 01.2267*)

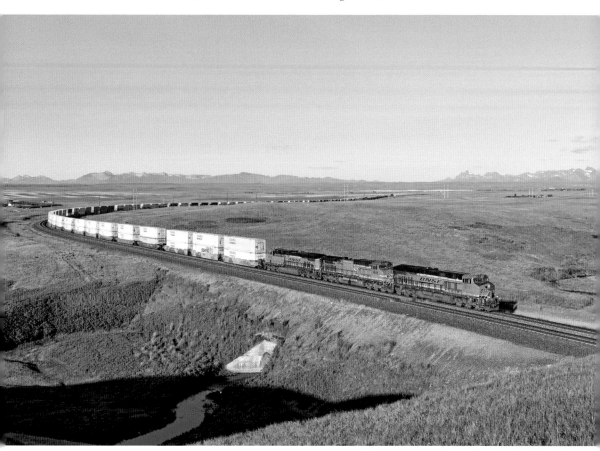

Above: A Burlington Northern and Santa Fe freight train passes near the location of Camp Disappointment near Browning, Montana, the farthest north point reached by members of the Lewis and Clark Expedition. The mountains of Glacier Park are those on the right quarter of the photo, from Marias Pass (the low point at the end of those mountains) northward to the Two Medicine valley. (*Justin Franz photo, taken in 2019*)

Right: Design of the front of the Sacagawea U.S. dollar coin, shown without year of issue or mint markings. (*United States Mint, Pressroom Image Library*)

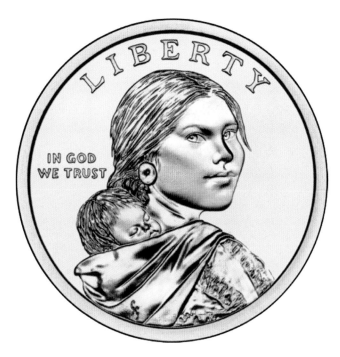

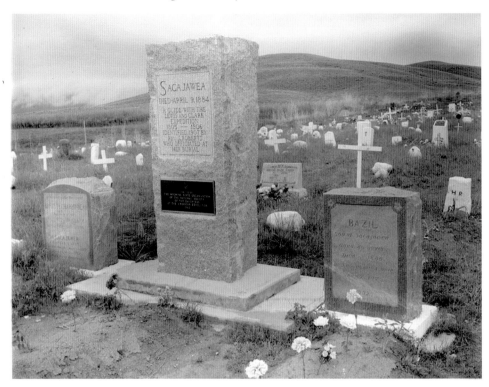

Sacagawea's grave, Wind River Indian Reservation, Fort Washakie, Wyoming. (*Photo by Phillip C. Johnson 1968-06-04, MHS umt015903*)

Bird Woman Falls, *right of center*, emerges from Bird Woman cirque, as viewed from Going-to-the-Sun Road in Glacier Park climbing the west side toward Logan Pass. (*Photo by author, August, 1981*)

Pitamakan

Pitamakan (a variety of spelling variants exist, including Pi'tamaka; here I use the spelling as applied to features in Glacier National Park), or Running Eagle, was a Pikunni Blackfeet woman who lived in the 1800s in the area near modern-day Glacier Park. She was also known as Weasel Woman. She is called in some circles the Blackfeet Joan of Arc because she never married and became a warrior and raider who went on raiding and war party forays with the men of the tribe. When she was twenty, a Pikunni raiding party headed over the mountains of Glacier Park to steal horses from the Flathead Kootenai. She trailed behind them and asked to join the raiding party. At first refused, a medicine man vouched for her presence with the raiders, noting essentially that he had a good feeling about her. She succeeded in stealing six horses on the raid, and upon returning to the Pikunni lands, she was welcomed as a warrior and given a male warrior's name, Running Eagle (Pitamakan), the only Blackfeet woman so honored.[5]

Directed by the tribal elders to go on a vision quest to learn her destiny, Pitamakan slept in a cave under a waterfall between Two Medicine Lake and Lower Two Medicine Lake in what is now Glacier National Park, where she received a vision that empowered her to subsequently lead several successful raids. She was ultimately killed on her ninth such raid by Flathead Kootenai, sometime after the late 1870s. The waterfall where she received her vision, in the cave beneath the waterfall, is now named after her—the former Trick Falls, renamed as Running Eagle Falls in her honor by the National Park Service in 1981. Pitamakan Lake and Pass are nearby locations in the park also named after Pitamakan, the Blackfeet Joan of Arc.[6, 7, 8, 9]

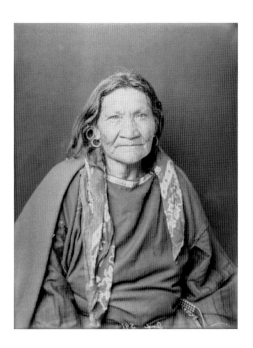

Photograph of Pitamakan, undated. (*Sid Richardson Museum, Fort Worth, Texas*)

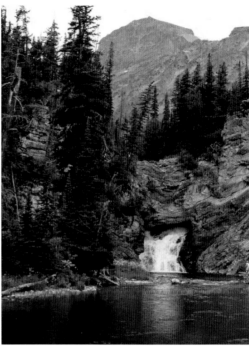

Views of Running Eagle Falls, named for Pitamakan, in the Two Medicine valley between Two Medicine Lake and Lower Two Medicine Lake. Left, hand-colored photo of Running Eagle Falls at high water, hiding the "trick" of the cave and lower falls beneath; right, photo of Running Eagle Falls at low water, revealing the cave underneath. (*Left, T.J. Hileman photo, author's personal collection; right, photo by author, July 31, 2000*)

"Princess Dawn Mist"

A lovely waterfall in the Belly River valley of northern Glacier National Park is named Dawn Mist Falls. Interestingly enough, the name is tied into a complex veil of deception woven by the Great Northern Railway in its push to advertise the park and to link the Blackfeet Indians ever closer to the identity of the park in the public mind's eye. The railway advertised the Blackfeet as "Glacier Park's Indians," and their advertising program to link the two (tribe and park) together was inexorable.

The name Dawn Mist comes from a novel written by Helen Fitzgerald Sanders, *The White Quiver*, published in 1913. The book is a fictional tale of a Blackfeet hero, White Quiver, and his love interest and the story's heroine, Dawn Mist. The book was supported by the Great Northern Railway, and the railway's president Louis Hill provided pictures of Blackfeet tribal members, posed in Glacier Park and photographed by Roland Reed, to Ms. Sanders to illustrate her novel, with the understanding that the novel would be sold by the railway in and around its Glacier Park hotel and chalet properties. The first photograph in the book is a picture of a Blackfeet maiden labelled "Dawn Mist." A subsequent similar photograph, sold as a postcard by the Great Northern, is labelled "Dawn Mist, Blackfeet Indian Princess." Later photographs of the same woman at times even

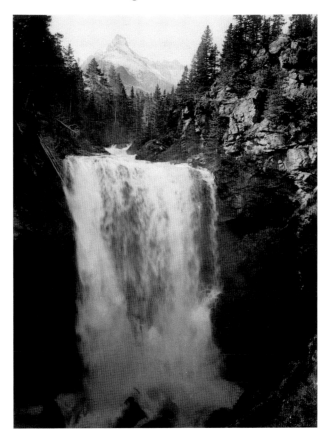

Dawn Mist Falls on the
Belly River, in northern
Glacier National Park, 1913.
(*Photo by Fred Kiser, OHSL
ba020877*)

labelled her as "Queen of the Blackfeet," although others continued to refer to her
as a princess.[10, 11, 12]

The woman in the early photographs was actually a Blackfeet woman, not
named Dawn Mist, but rather Daisy M. Norris. She was hired to pose as Princess
Dawn Mist by Great Northern publicist Hoke Smith, who created the fictional
persona of Princess Dawn Mist, drawing from Helen Fitzgerald Sander's novel and
wrote stories about her that circulated across the country in newspapers hungry
for information about the "Wild West" and its real Native American tribes. The
public did not know that the individuals involved in Smith's stories, including
Princess Dawn Mist, were completely fictional, designed to further imprint in the
public mind the connection between Glacier Park and the Blackfeet.

"Dawn Mist" traveled around the country with other tribal members, attending
public functions and "spreading the word" about "Glacier Park's Indians." For
Daisy Norris, it was a good-paying job during a period when good-paying jobs for
Blackfeet women were few and far between. Hoke Smith even fabricated a story
out of thin air that Dawn Mist would ride, in buckskin, in a 1913 Washington,
D.C., suffragette parade with other tribal members, and that story was widely
circulated in the press. The parade did indeed occur, but Dawn Mist and other
Blackfeet never in fact participated. Norris later married, becoming Daisy M.

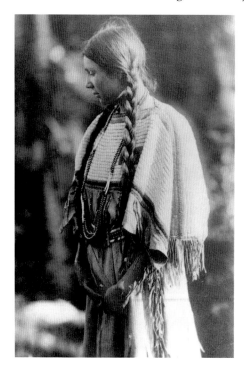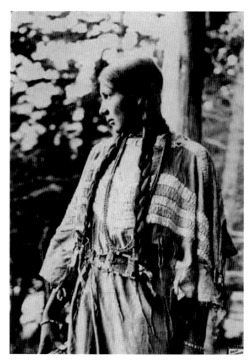

Two photos of Dawn Mist, as played by Daisy M. Gilham. Left, unattributed photo taken 1914; right, postcard photo taken *circa* 1912-1915. (*Left, public domain photo; right, GNR, photo by Roland Reed, University of Washington Libraries Special Collections Division*)

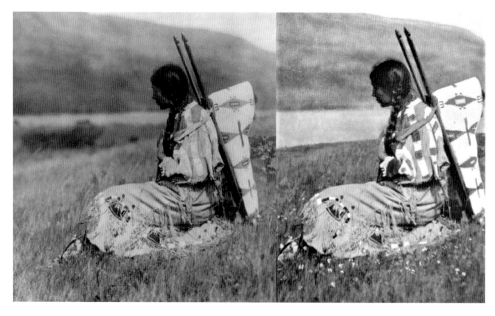

Two versions of the same photo of Dawn Mist, taken in 1915. The right-hand photo was hand-colored and sold as a postcard, and on it Dawn Mist has been "promoted" from a Blackfeet Princess to "Queen of the Blackfeet". (*Photos in public domain, but from GNR and probably taken by Roland Reed*)

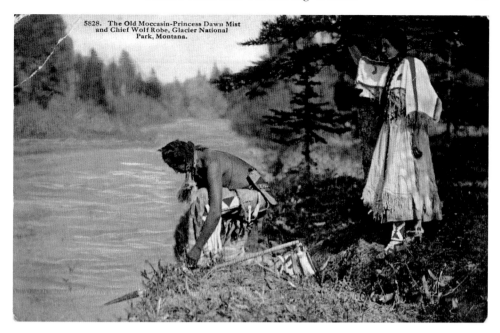

5828. The Old Moccasin-Princess Dawn Mist and Chief Wolf Robe, Glacier National Park, Montana.

Dawn Mist and Chief Wolf Robe in Glacier National Park, probably along either the St. Mary River or Cut Bank Creek where similar photos were taken. (*Photo undated, GNR and probably taken by Roland Reed*)

Norris Gilham and settled down and raised a family. That led, of course, to the need to replace her in the churning Great Northern advertising machine.[13]

Blackfeet tribal member Irene Goss replaced Daisy Norris Gilham as Princess Dawn Mist sometime in the 1920s. As Dawn Mist, Goss went on extensive tours with roughly three dozen Blackfeet tribal members to major cities throughout the northeastern and midwestern United States and was "the face" of the touring group. Meeting with dignitaries from numerous cities, she and tribal members would initiate local politicians into the Blackfeet tribe, often with a headdress gift. Of particular note was a meeting between Goss and tribal members with U.S. President Calvin Coolidge on September 17, 1927. When Goss subsequently married, her unnamed sister replaced her in the role of Dawn Mist. Cahill noted in her book on the early twentieth-century suffrage movement and the role of women of color in that movement:

> For Daisy and the Goss sisters, playing Dawn Mist was a job and maybe a good one. It was not hard work like cleaning houses, picking sugar beets, or working for the Bureau of Indian Affairs, but it did mean engaging with the public—many of whom were incredibly ignorant.[14]

In that sense, Daisy Norris, Irene Goss, and her sister were most definitely pioneering women—Blackfeet women who traveled widely across the country, and lived a well-paid and comfortable life in an era when such conditions were (and unfortunately largely continue to be) few and far between for female tribal members.

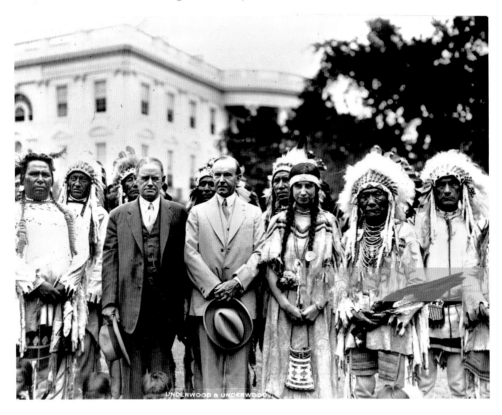

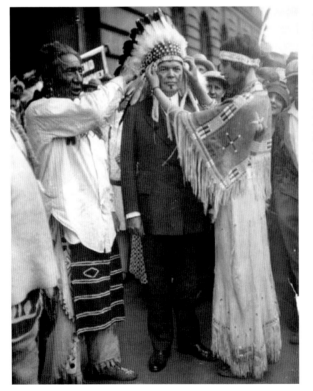

Above: This photo, taken on September 17, 1927, shows President Calvin Coolidge at center, with Commissioner of Indian Affairs Burke and Blackfeet Indians (*front row*): Owen Heavy Breast, Princess Dawn Mist, Chief Bird Rattler, and Two Guns White Calf, with the White House in the background. This version of Dawn Mist is Irene Goss. (*Library of Congress LC-USZ62-90479, photo by Underwood and Underwood*)

Left: Captioned "Princess Dawn Mist decorates City Manager Hopkins," on the reverse was noted "W.R. Hopkins becomes a brave." Irene Goss also played Princess Dawn Mist here. Photo taken September 18, 1927. (*Cleveland Press Collection, Michael Schwartz Library, Cleveland State University*)

2

Pioneering Women
Homesteaders and Settlers

As mentioned in the introduction, the Glacier Park's west-side pattern of settlement allowed fairly extensive homesteading prior to the creation of the park in 1910, especially "up the North Fork" in the meadows along the Inside North Fork Road east of the North Fork of the Flathead River. The Inside Road, built in 1901, was not built for homesteaders but for commerce—for access to the oil seeps in, and delivery of oil exploration equipment to, the Kintla Lake region. The Inside Road was merely a "cut through timber" in most places and remains that to this day. Nonetheless, it allowed homesteaders easier access to the meadows of the North Fork than had previously existed.[1, 2]

North Fork Homesteaders and Pioneering Women

Roughly three dozen homesteads were filed in the North Fork country along the Inside North Fork Road in the early 1900s. These included some notable homesteads that still stand today. By the 1950s, most of these had been abandoned and purchased by the National Park Service in order to include them in the acreage of Glacier National Park. The Red Bench Fire of 1988 removed the evidence of many of the structures. The Matejka cabin at the foot of the Trout Lake trailhead along the Inside Road, and the McCarthy homestead are some of the few remaining structures fully standing, although debris or foundations from others, such as the Walsh cabin, can be located by persistent searching.[3, 4]

Homesteads were usually family units, wherein the pioneering women enter the picture. Most homesteads were filed by the husband because women at this time still had not secured the right to vote. Their work in this remote location was, however, crucial to the success of a homestead. One representative example is provided by the McCarthy homestead filed in 1908 for 130 acres on the south end of Big Prairie. Unfortunately, Jeremiah McCarthy, the filing husband, died in May

1909. In order to maintain and keep the homestead, his wife Margaret McCarthy tilled the required number of acres in 1909, built a fence and garden in 1910, fenced more land, and prepared 2 acres to seed (along with a garden) in 1911. In 1912, she built 1 mile of fence and prepared 9 acres for cultivation. The year 1913 saw Margaret seed 15 acres with oats and timothy. She received the final proof certificate of ownership in 1913. Mrs. McCarthy died in 1939, but her children and grandchildren continued to use and improve the property until 1970, when it was sold to the National Park Service. Elsewhere, the economic turbulence of the Great Depression and World War II took their toll on homesteaders, such that by 1954, there were no year-round residents living on the east side of the North Fork valley. Women homesteaders "up the North Fork" lived a demanding life, but their efforts made such homesteads possible for over forty years.[5, 6]

An important economic center for the North Fork residents was the local store, founded first as the Adair Mercantile along the Inside North Fork Road in 1904 by William Adair and his first wife, Jessie. Located in Sullivan Meadow just south of Logging Creek, it was roughly equidistant from the northern homesteaders up around Big Prairie, and the southern homesteaders around Camas Creek. The Adair Mercantile was an overnight stopping point for visitors traveling the rough Inside Road northward from Apgar on their way "up the North Fork."

> When we reached the Adair place, it was evening and we stayed all night there. Bill Adair and his wife Jessie ran a stopping place and a small store near where the

Typical North Fork meadow environment, here near Anaconda Creek, for which homesteaders filed claims and built cabins and small ranches. (*Photo by author, taken July 26, 1994*)

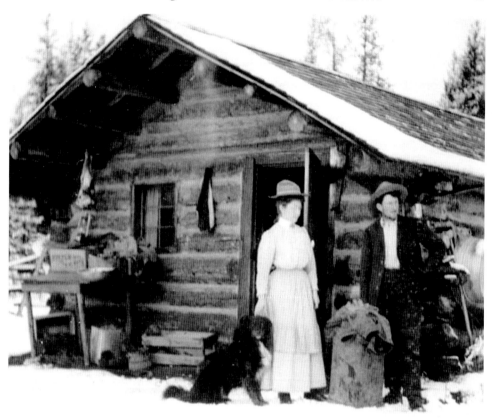

North Fork homesteaders John and Harriett Walsh, 1909 or 1910. Their cabin was homesteaded in Big Prairie in 1906. (*Photographer unknown, NPS*)

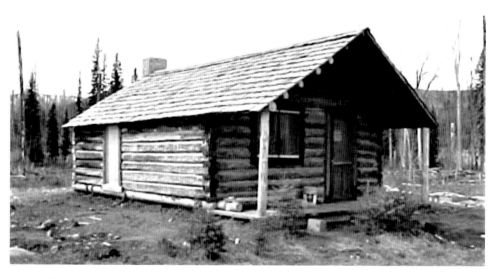

McCarthy Homestead cabin, built in 1908 by Jeremiah McCarthy on the southern edge of Big Prairie on the Glacier Park side of the North Fork of the Flathead River. (*Photographer unknown, NPS public domain*)

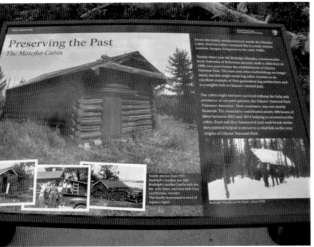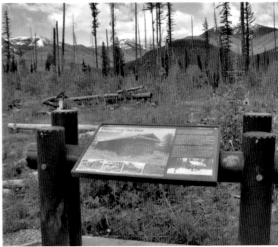

The Matejka cabin is located about 1 mile above the junction of the Inside North Fork Road and the Trout Lake trailhead, along the Trout Lake trail below Christensen Meadows. *Left,* informational sign describing the Matjeka cabin, built in 1908; *right,* location of the sign for the Matejka cabin, at the junction of the Inside Road and the Trout Lake trail. (*Both photos from Glacier National Park Volunteer Associates, taken July 16, 2020*)

Sullivan ranch is now. Early travelers going up and down that road will never forget Mrs. Adair's good meals.[7]

"Bill" Adair was a large personality, who loved fishing, conversation, and drinking. It is said that his wife Jessie, and later his second wife Emma, ran the mercantile—Jessie running the original Adair Mercantile inside Glacier Park; and after 1914, Jessie and subsequently Emma running the Polebridge Mercantile on the west side. The Adairs relocated across the river in 1912 to avoid the restrictions in the new national park, building a new homestead cabin, and the new mercantile was built and opened south of their cabin in 1914. The Adairs continued to run the store until just after World War II when new owners took over. Both the Mercantile and the cabin, reincarnated as the Northern Lights Saloon, are focal points of modern Polebridge, reached still by gravel road, but today up the west side of the river only (the Inside Road is currently impassable between roughly the Logging Ranger Station on the north and Camas Creek on the south).[8]

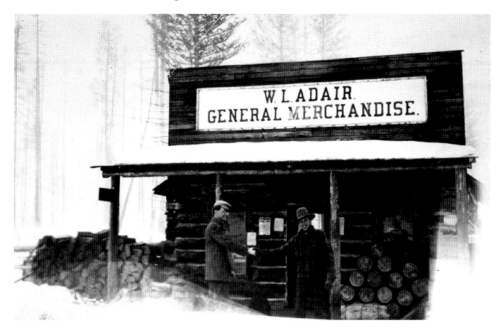

The Adair Mercantile, built in 1904 and run by William Adair and his first wife, Jessie. The Mercantile was located in Sullivan Meadow, south of Logging Creek, along the Inside North Fork Road. (*Photographer unknown, NPS Archives*)

Bill Adair and his second wife, Emma, at the Polebridge Mercantile after Adair moved his business from Sullivan Meadow to the west side of the North Fork of the Flathead River and finished building "The Merc" in 1913 or 1914. (*Photographer and date unknown, Polebridgemerc.com*)

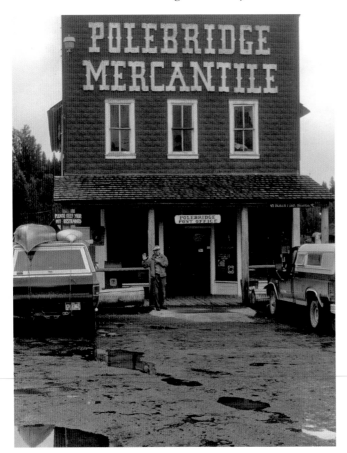

Left: The Polebridge Mercantile in 1988, photo taken on a rainy day on July 5, 1988. (*Photo by author*)

Below: The Northern Lights Saloon in Polebridge, north of the Mercantile, was originally built as a homestead cabin in 1912 by William Adair and his wife, prior to moving their business to Polebridge in 1914. The building served as an owner's cabin until the 1950s, when it was converted to a rental cabin. It was converted into the Northern Lights Saloon in 1976. (*Photo by author, taken July 20, 1988*)

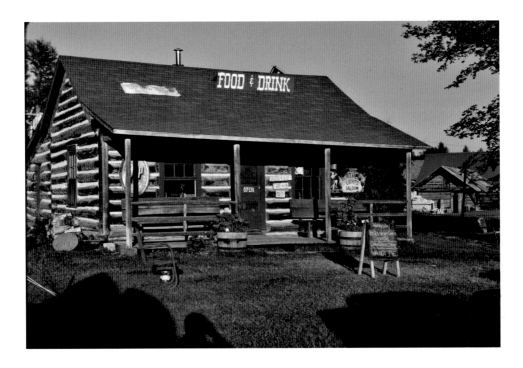

Developments and Pioneering Women Around Lake McDonald

South of the North Fork region, the greatest concentration of development and homesteads was around the shores of Lake McDonald. Historical reports for this area typically focus on the men who established the area settlements, but women were also present albeit often, and unfortunately, anonymously. A few women rose to fame or notoriety in the area, although the history of women around Lake McDonald deserves much greater attention by scholars. The 1890s and early 1900s were a challenging time for anyone in the area, but particularly so for women. Sadly, historical reports of the pioneering women of those times are few and far between, but include the reminisces of early settlers in Harrington's history of Apgar and stories presented by Fraley in his book on pioneers of the Middle Fork.[9, 10]

Homesteads on the shores of Lake McDonald were established prior to park creation in 1910, in the 1890s and early 1900s. Among the most significant early homesteads, for which women were actively involved in their operation and success, were the Howe (or Howes, there are differing versions of the name in the historical literature) and Apgar homesteads in the village of Apgar near the mouth of Lake McDonald, the Snyder homestead and subsequent Glacier Hotel at the present-day Lake McDonald Lodge complex, and the Geduhn and Comeau homesteads at the head of the lake. In Apgar, Mrs. Maggie Howe and Mrs. Diane Apgar were mainstays in the newly settled collection of homesteads. Both families built several tourist cabins, the Apgars on the west side of the lake outlet and the Howes on the east side, which they rented to visitors and for which both Maggie and Diane provided well-prepared meals of renown in the area. Mrs. Apgar was especially well known for the best and reasonably priced meals in the McDonald valley.[11, 12]

Maggie Howe, wife of Charlie Howe, was half Chippewa and came with her husband from northern Wisconsin when she was but sixteen years old. One visitor reported, with reference to Maggie Howe:

> Maggie was a fine housekeeper and a good cook and for our breakfast we usually had fried venison and sour dough hot cakes. Maggie was half Chippewa … She often told me of the hardships she endured those first years when they lived in a crude log cabin on the point … However, by the time I met them, they lived in a nice cedar log cabin, very rustic. They even had the luxury in having a sink and a hand water pump in the kitchen.[13]

At the head of Lake McDonald, on the west and east shore adjacent to where McDonald Creek enters the lake, respectively, the Geduhns and the Comeaus established homesteads and cabin camps. Mrs. Lydia Comeau was known as a strong-willed, independent woman who brooked no nonsense. A photo of her, broom handle firmly in her hand, at George Snyder's Glacier Hotel, speaks of a woman of quiet strength and determination. Her strength and determination were on display in a story relayed by John Fraley. He recounts that George Snyder would bring supplies by boat to the Comeaus at the head of the lake. Unfortunately, the Comeaus had a shallow launch area that could not accommodate Snyder's 40-foot steamer with

attached barge carrying supplies. Normally, Denny Comeau would row out from the shallows to the steamer and transfer the supplies into his smaller boat. However, on one such trip Denny Comeau was away, so it was up to Lydia Comeau to row out and carry out the transfer of necessary supplies for them and for their guests at the cabin camp, confirming her reputation as an "all around roustabout."[14]

Another pioneering woman of note in the Lake McDonald area was Nancy Russell, wife of the famous Cowboy Artist, Charlie Russell. The Russells had a cabin built, from land provided by the Apgar family, on the northern shore of the lake near Apgar village, and spent virtually every summer there from 1906 onward. Nancy Russell is examined in more detail, however, in a subsequent chapter in this book.

The first schoolteacher in Apgar was Mrs. Leona Tidrick Harrington. She came to Apgar in 1914 due to an ill sister in the village and was persuaded to start a private school to serve the needs of the children of the early pioneer families there. Later that year, the school was built, the only school ever built within Glacier National Park, and she worked there as teacher until the end of the school year. She left then and married Charles Harrington, but returned as teacher in the schoolhouse upon his death in 1946. She taught there until the school was consolidated with the West Glacier school district in 1958. As the first teacher in Apgar, she was truly a pioneering woman in what was still a near-wilderness at that time. She also organized the publication of *The History of Apgar*, a collection of letters written by Apgar old-timers in 1950 and added to through 1957.[15]

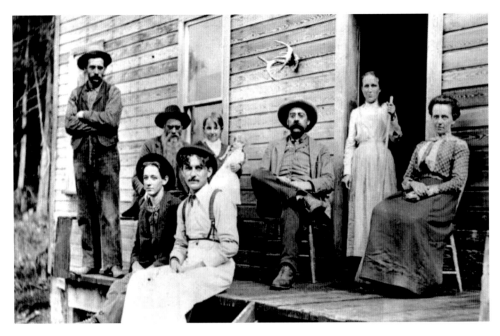

Group on the porch of George Snyder's Glacier Hotel, on the shore of Lake McDonald, *circa* 1910. *Back row, left to right,* Denny Comeau, Thomas "Uncle Jeff" Jefferson (with beard) sitting with Ruth Cruger, A. M. Day, Mrs. Lydia Comeau, Mrs. Day. *Front row,* Eddie Cruger and Bert Jesmer (cook, in apron). (*GNP*)

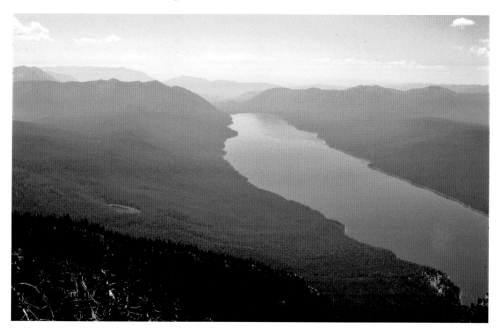

Lake McDonald viewed from near the top of the Mt. Brown Lookout trail, July 26, 1998. The Lake McDonald Lodge area is the complex on the fan-shaped feature at lower right. The village of Apgar (not visible in the picture) is located at the far end of the lake, at upper center in the photo. (*Photo by author*)

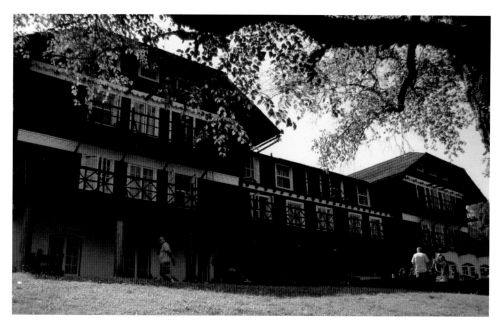

The impressive lakefront side of Lake McDonald Lodge. Visitors are often surprised to see that the "backside" of the lodge is more impressive than the "front side" to which one can drive up. This seeming contradiction is because that, until the 1920s, almost all visitors arrived at the lodge by boat on the lakeside, and thus the lakeside front was truly the "front door" entrance to the lodge. (*Photo by Mike Butler, taken July 23, 2012*)

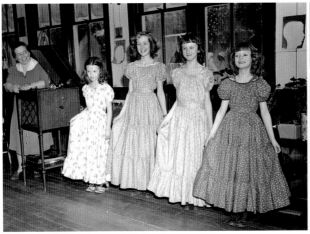 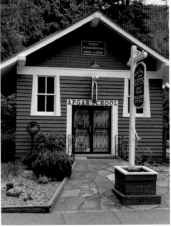

Left, Teacher Leona Harrington admires the girls at a square dance at Apgar School in Glacier National Park on Jan. 16, 1950. Note the hand-cranked phonograph on which she is leaning. *From left*, the students are Donna Brewster, Djaron Davis, Elaine Anderson, and Susan Davis. *Right*, the Apgar school had an enrollment of ten students, and today, the former school is a gift shop. (*Left, Hungry Horse News, Mel Ruder photo; right, walkerhomeschoolblog.wordpress. com, photo unattributed*)

The Cattle Queen of Montana

Probably the most infamous female resident of the Lake McDonald area is worthy of special attention here. Elizabeth "Libby" (Mrs. Nat.) Collins, the "Cattle Queen of Montana," was a resident of Choteau, Montana, where she raised cattle (and there earned her nickname, becoming the first woman allowed to accompany cattle for delivery eastward by successfully petitioning the Great Northern Railway for permission to do so). Her real passion, however, was seeking mineral riches, especially gold.[16]

In 1895, Libby Collins became a partner in a mining claim and operation in what would later become Glacier Park, with her brother Chandler Smith and a prospector named Frank T. McPartland (for whom McPartland Mountain in the McDonald Creek drainage of Glacier Park is named), whom Libby had met in Choteau. McPartland apparently located the claim (although some sources state that it was found by Libby Collins) at the head of a tributary creek to McDonald Creek subsequently named Cattle Queen Creek, and got Libby and her brother to invest in developing the claim. Libby Collins had a crew clear a trail from the head of Lake McDonald, where McPartland had a few cabins, to the head of the McDonald Creek drainage up Cattle Queen Creek (although one source says the trail was planned and cut by McPartland and about half a dozen other men). Collins had two cabins built near the mining prospect. Results from the claim were not good, which led to the notorious events of August 5, 1895. [17, 18]

Stories are scrambled about what precisely occurred that day in August 1895. It is likely that Libby and her partners had been drinking heavily and complaining

about the lack of results up to then at their mining claim. For some reason, they got in a boat on Lake McDonald adjacent to George Snyder's Glacier Hotel and argued sufficiently loudly that people at the hotel became aware of the quarrel on the lake. Somehow, the boat overturned and dumped all three occupants into the cold water of the lake. McPartland apparently grabbed onto Libby Collins, perhaps to save himself, but she was able to shed his grasp and he unfortunately drowned. Libby's brother Chandler Smith, and others who came out onto the lake from Snyder's Glacier Hotel, were able to save Libby. Debate continued for years as to whether Libby deliberately drowned McPartland or was desperately trying to save herself from his panicked grasp.[19]

Collins is said to have worked the claim on Cattle Queen Creek for three summers and one winter, with Snyder's hotel as a base of operations. After bringing in a mining expert, who pronounced the claim worthless, Collins abandoned the area and headed to Alaska, still in search of gold. She eventually returned to her ranch in Choteau, and came back to Lake McDonald and Snyder's hotel periodically for several years, with the last reported sighting of her there in 1925. In the 1950s, a Hollywood film was made about the "Cattle Queen of Montana," but like many movie offerings, it had virtually nothing to do with Libby Collins' actual life except for sharing the nickname.[20, 21]

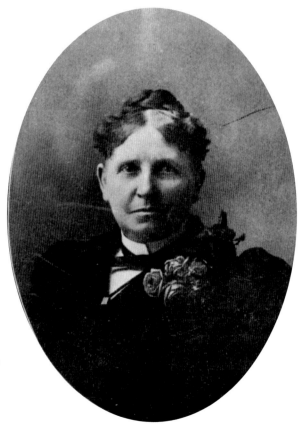

Portrait of "the Cattle Queen of Montana," Elizabeth "Libby" (Mrs. Nathaniel) Collins, *circa* 1911. (*Photographer unknown, Denver Public Library Special Collections ZZR711000163*)

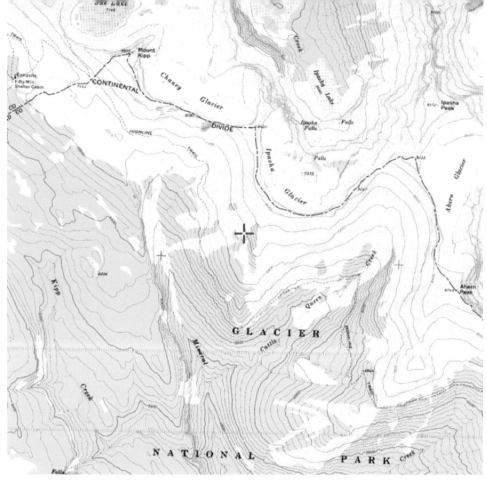

U.S. Geological Survey 1:24,000 topographic map (*above*) and helicopter photo (*below*) of Cattle Queen Creek in Glacier Park, at the head of the McDonald Creek valley. The Cattle Queen's mineral claim was at an unspecified location in the Cattle Queen Creek drainage. (*Above, USGS; below, photo by author, August 9, 1995*)

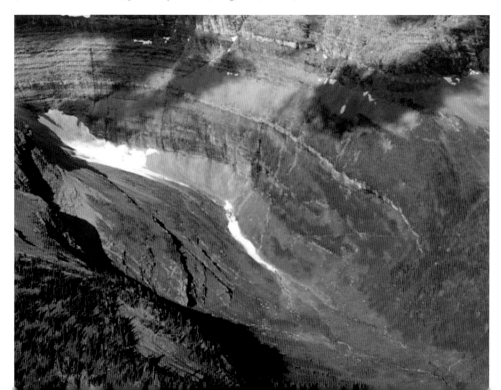

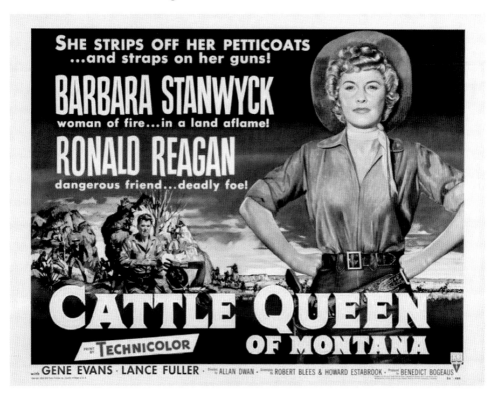

Movie poster (*above*) and publicity photo (*right*) for the 1954 film *Cattle Queen of Montana*. The film starred Barbara Stanwyck and an actor named Ronald Reagan, shown in the photo from location shooting on the Blackfeet Reservation just east of St. Mary on the east side of the park, even though the actual "Cattle Queen" lived and mined on the west side of Glacier Park. Although supposedly about Libby Collins, the film had virtually nothing to do with actual events in her life. (*Above, RKO Radio Pictures; right, photo by Mel Ruder, Hungry Horse News*)

Homesteading on the Middle Fork

Distinctly fewer homesteads within the boundaries of Glacier Park occurred south of Lake McDonald along the Middle Fork of the Flathead River. Instead, nearly all such homesteads occurred on the broad floodplain areas west of the river near or adjacent to the tracks of the Great Northern Railway. One prominent exception was the Dan Doody homestead near the mouth of Harrison Creek, within Glacier Park, but Doody was for a period of time a Park ranger, and his wife Josephine is examined in a subsequent chapter devoted to early ranger wives. That homestead was the only prominent one in the park between Belton and the village of Essex on the southern tip of Glacier Park (labeled as Walton, after the ranger station of that name, on the map at the front of this book). Homesteaders and subsequent developments at places such as Nyack, Stanton Creek, Pinnacle, and Essex benefitted from access to the railroad and subsequently to U.S. Highway 2, an advantage that the North Fork homesteaders did not have. Some of those developments, outside the park, have been covered in a pair of fine books by John Fraley, and interested readers are referred to those works.[22, 23]

Notch-cut and sawed stumps in a small clearing along the east side of the Middle Fork of the Flathead River, possibly part of a short-lived homestead across the river from the modern Paola River Access Boating Site. (*Photo by author, July 6, 1988*)

An Eastside Pioneering Woman

Unlike on the west side of Glacier Park, little land was available for homesteading on and along the east side of the park. The presence of the Blackfeet Reservation immediately bounding the eastern border of the park precluded homesteading on the reservation. Homesteading was restricted to a small area on the southeastern edge of the park, from the border of the reservation south of Glacier Park/East Glacier Park to the Continental Divide at Summit. That area is part of the Lewis and Clark National Forest, established in 1897 as the Lewis and Clark Forest Preserve, but the area was open to homesteading in the early 1900s. Although not within Glacier Park, unlike the North Fork and Middle Fork homestead inholdings, the homesteads boasted spectacular views of the Lewis Range, with vistas from Summit Mountain on the south to Dancing Lady Mountain west of East Glacier Park. The homesteads were concentrated around Lubec Lake, a source of water and relatively flat land. A total of seventeen homesteads were filed and proved up in 1913.[24]

Homesteaders around Lubec Lake were several miles from East Glacier, a considerable distance in the early 1900s, especially in winter. U.S. Highway 2 did not yet exist southwest of East Glacier Park (then still known as Midvale prior to 1911, and as Glacier Park until 1949 when the new name was adopted). The Great Northern Railway ran through the homesteaded area, but without stops.

Lubec Lake, with the remnants of the Smiley bunkhouse on its shore near center, as viewed from the nearby railroad tracks (formerly the Great Northern). The mountains of southeastern Glacier Park loom immediately nearby. (*Chris Peterson photo, Hungry Horse News, September 27, 2016*)

However, the steam trains of the early 1900s labored as they climbed toward the Continental Divide at Summit, and also had to slow down for a curve in the tracks. Local homesteaders would go out onto the platform at the end of a passenger car on the railroad, and when the train slowed for the curve, they jumped off and landed and rolled to a stop.

A small community of homesteaders—anchored by the Smileys, the Hydes, the Pikes, and the Fountaines—was developed around Lubec Lake, and a ranger station for the forest preserve was built there in 1909. Clara Augusta Miller Smiley, wife of Glen C. Smiley, was one of the remarkable homesteading women who reached their home by jumping off the train. Married in 1915, Clara and Glenn Smiley arrived at Lubec on the Great Northern, at which point they had to jump off the slowly moving train. Clara was terrified, but successfully made the maneuver, the first time of many in her life (and later including with her young son and infant daughter, who were tossed off the train to be caught by their waiting father).[25]

The Smiley homestead was "proved up" in 1919 and registered by Glenn in Clara's name, but soon thereafter a gradual transition occurred, which by 1921 saw the family moving to (East) Glacier Park. There, along with nearly all the local residents, the Smileys made their living through working at odd jobs for the adjacent young national park in the summer as well as engaging in local commerce. Glenn became partners in the local meat market, and Clara became well known for her baking. Eventually they established the Glacier Cash Grocery in 1924, a block east of the Glacier Park Trading Company on U.S. Highway 2 (two blocks counting the alley behind properties fronting on Highway 2). They also rented rooms in the building, where Clara continued to live until 1962 when her declining health led her to move to a rest home in Cut Bank, near which she is buried. The Glacier Cash Grocery is now the Brown House, which offers rooms for rent and which maintains the Smiley Memorial Museum, full of photos and mementos from Clara's life there, as well as local art and pottery made by the current owner.[26]

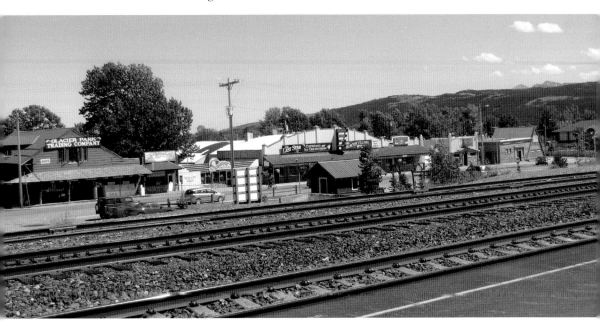

The commercial center of East Glacier Park, aligned along U.S. Highway 2, as viewed from the Glacier Park Station railroad terminal. The former Glacier Cash Grocery, now the Brown House, is out of view a block behind the Glacier Park Trading Company. (*Photo by author, July 21, 2012*)

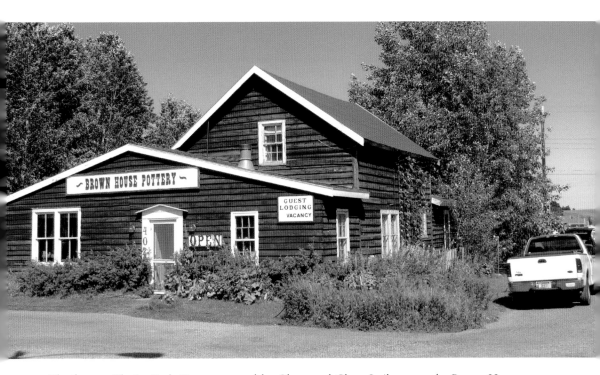

The former Glacier Park Grocery owned by Glenn and Clara Smiley, now the Brown House, which contains the Smiley Memorial Museum. (*Photo by author, July 21, 2012*)

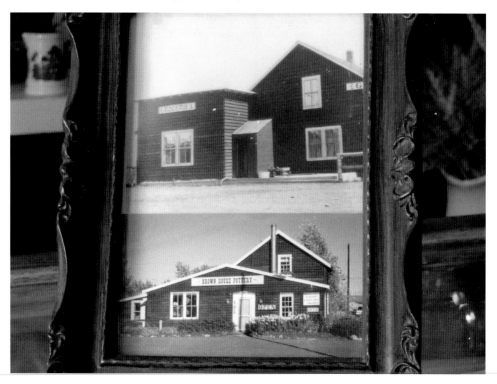

A "then and now" set of photos in the Brown House Smiley Memorial Museum, illustrating the Glacier Cash Grocery and as remodeled into the current Brown House. (*Photo by author, July 21, 2012*)

Photo of Clara Smiley from her days baking and helping run the Glacier Cash Grocery, on display in the Brown House. (*Photo by author, July 21, 2012*)

3
Ranger Wives:
Pioneers of a New National Park

From the beginning, and even prior to the creation, of Glacier National Park in 1910 until about 1940, ranger stations around the park were staffed by rangers year-round, regardless of the weather. All those rangers were male. The first female rangers were not even employed in the park until the 1960s and 1970s—the first female ranger naturalist was hired in 1964, and it took until 1979 for the first female law enforcement ranger to be hired.

Poaching was a prominent concern in those early park days, and most poaching would be done with traps and traplines set out over winter, when furs of animals were at their most luxurious. Thus, rangers patrolled their territory year-round. Some of those early rangers were bachelors, like Joe Cosley, but many of the early rangers were married and their wives lived in the ranger stations with them year-round. In some cases, these pioneering wives endured amazing hardships and loneliness. Some of these wives assisted their husbands by accompanying them on their daily patrols around portions of the park, and by writing the daily log entries in the ranger logbooks, all the while also taking care of children (not all stations had children present), producing the meals, mending clothes, and in general providing care for their husbands. These women occupied ranger stations on both sides of the park, although often somewhat anonymously. I will examine here several ranger wives for whom some detailed information exists, in roughly chronological order from the final days of the Flathead Forest Reserve (pre-1910) and earliest days of the park through the 1930s.[1, 2, 3, 4]

Lulu and Frank Liebig

Prior to the formation of Glacier National Park, the first and most prominent ranger was Frank Liebig, the Flathead Forest Reserve ranger for roughly two-thirds of the acreage of today's park, from the Canadian border to south of St. Mary Lake, and from the North Fork of the Flathead River eastward to the western boundary

of the Blackfeet Reservation. He lived in a cabin at the head of Lake McDonald, designated the Mount Stanton Ranger Station, roughly where the current Lake McDonald Ranger Station is located at the head of Lake McDonald.[5, 6]

The winter of 1906–1907 was extremely cold with very heavy snows, making patrolling from his ranger station impossible for Frank Liebig. He moved into Kalispell for the winter, close to the forest reserve headquarters. In Kalispell, he rented a house from a man with daughters of eligible age for courting. Frank became enamored of Lulu May McMahon, the landlord's eldest daughter. Their romance blossomed, and they were married June 6, 1907. After a honeymoon at the Belton Hotel, Frank and Lulu took up residence at the Mount Stanton Ranger Station.[7]

Married life for the Liebigs was a true partnership, with Lulu accompanying Frank on many of his patrols year-round. She also ran her own trap lines for furs to supplement their income, focusing especially on trapping martens (a member of the mink family). During forest fires, Lulu would serve as camp cook for the men fighting the fires. Two children were born during this period of the Liebig's residency at the head of Lake McDonald; when her time was due, she and Frank twice made the two-day trip to Kalispell to the doctor who oversaw the births, and after about three weeks for each birth, the Liebigs and their newborn daughter made their way back to the Mount Stanton Ranger Station and the girls were raised there. This life continued until 1910, when Glacier became a national park. As an employee of the Forest Service, Frank's services were discontinued by the new park, and the Liebigs moved to Kalispell in the fall of 1910. A third daughter was born there, and Frank continued a long and distinguished career with the Forest Service.[8, 9]

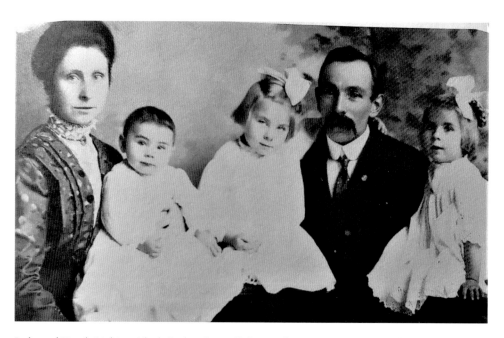

Lulu and Frank Liebig with their daughters (*left to right*) Margaret, Jean, and Frances, in 1912 or 1913. (*GNP Archives, Liebig collection*)

Josephine and Dan Doody

Josephine Gaines was born in Macon County, Georgia, in 1854 (although some evidence points to a birth in 1848). She traveled west to Colorado in the 1870s, where she unfortunately had to turn to prostitution for a living in dance halls, saloons, and brothels. She ultimately fled Colorado after shooting and killing a man in Pueblo, although she claimed self-defense. Her flight led her eventually to Montana and the frontier railroad town of McCarthyville, near Marias Pass on what is now the southern border of Glacier Park, in 1890. There she resumed her career as a dance hall woman (and probably also prostitute), but also became addicted to opium. Nonetheless, she attracted the eye of a frontiersman, settler, and trapper named Dan Doody, who had a homestead near Harrison Creek, on the east side of the Middle Fork of the Flathead River. [10, 11]

In order to save Josephine from her life of drugs and prostitution, and because he was desirous of a wife, Dan Doody kidnapped Josephine and took her to his cabin across the Middle Fork from the Great Northern Railway village of Nyack. Doody locked Josephine up in a small subsidiary cabin where she underwent a "cold turkey" withdrawal from opium. After several weeks of that treatment, Josephine ultimately dried out from her addiction and settled into a domestic routine with Dan Doody, recognizing that his actions, barbaric though they were, likely saved her life. Although she claimed that they were married, it was apparently a common-law marriage, because no marriage certificate has ever been located. [12, 13]

Dan Doody became well known in the area as a trapper and guide with a great deal of knowledge about the local area, and his reputation attracted big game hunters including James J. Hill, president of the Great Northern Railway, which passed nearby and across the river from the Doody homestead. Hill in fact had the railroad build a siding stop for the Doody homestead to facilitate his visits across the river. [14, 15]

Due to Dan's local knowledge and tracking abilities, he was among the first group of park rangers hired in 1910, in spite of being well known not only for his tracking but also for his poaching abilities. He was, in fact, the first of six rangers hired by the new national park in 1910, and thus Josephine became the first ranger's wife of Glacier National Park. Dan continued to be annually re-appointed until his termination for unstated reasons (but probably because of his on-going poaching activities) on March 15, 1916. The Doodys continued, however, to live in their "inholding" enclave within the young national park, and Mt. Doody near Coal Creek in southern Glacier Park is named after them. Dan Doody passed away from a heart attack in 1921. [16] Josephine continued to live within the park until 1931, when she moved across the river to a cabin near the new U.S. Highway 2. In the winter of 1936, she developed pneumonia and was taken to a hospital in Kalispell, where she died on January 16th. The Doody homestead continued as a private land inholding within the park, however, until purchased and donated to the park in 2012. [17, 18, 19]

Two views of Josephine Doody's husband, Dan Doody, who was one of the first Park rangers after Glacier Park was established in 1910. (*Left, GNP NPSHPC - GLACHPF# 9463; right, GNP Archives*)

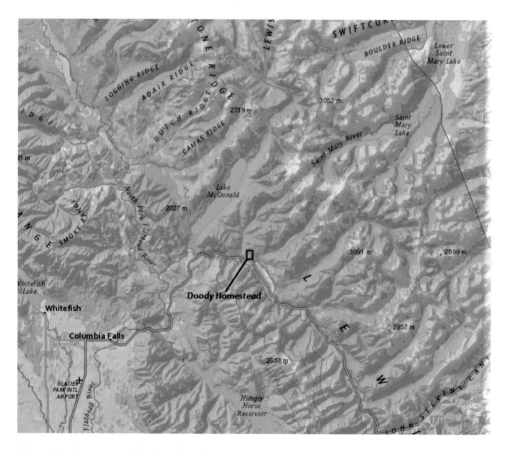

Map of the location of the Doody cabin, just inside the boundary of Glacier National Park at the mouth of Harrison Creek, along the edge of the east side of the Middle Fork of the Flathead River across from the tiny railroad village of Nyack. (*Map from National Park Trust*)

Oblique aerial view of Mt. Doody, located south of the Doody homestead and cabin between Harrison Creek and Coal Creek in Glacier National Park. (*Photo by Captain A.W. Stevens, U.S. National Archives 18-AA-78-28*)

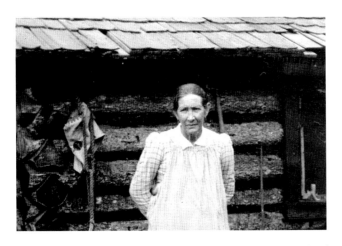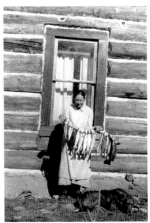

Josephine Doody outside the Doody cabin near the mouth of Harrison Creek. *Left*, Josephine Doody poses for the camera; *right*, Josephine displaying quite a catch of fish. (*Left, GNP, photographer unknown; right, photo from the Hungry Horse News, July 7, 2021, photographer unknown*)

Two modern-day alcohol-related products invoking the name of the Bootleg Lady of Glacier Park. (*Left, View of Mt. Doody from near/along U.S. Highway 2 around Coal Creek, photo from BiasBrewing.com; right, whiskey product carrying a very stylized image of Josephine Doody, photo from The Right Spirit*)

During the early 1900s, Josephine began a successful career as a bootlegger of "moonshine." News of her distilling abilities spread among workers of the railroad as well as with locals. Locals from Belton would travel 10 miles upstream by pumping handcars to purchase moonshine as well as to partake of Josephine's renowned home cooking, and railroad workers would stop at "Doody Siding," and order how many quarts of moonshine they desired by blowing on the train whistle, one blast per quart of moonshine desired. Josephine's bootlegging days continued well after park creation in 1910, and her fame as a bootlegger led to her being known as the "Bootleg Lady of Glacier Park". Her bootlegging finally ended on February 28, 1928, when rangers from the National Park Service were forced to assist federal agents ("revenuers") in shutting down her stills. During the shutdown raid, three stills were found along with twelve barrels of mash and a total of 18 ½ gallons of moonshine. For such moonshining activities, Josephine's reputation as the Bootleg Lady of Glacier Park continues to the present day, and her name is associated with locally produced alcohol products.[20]

Eva and "Chance" Beebe

Chauncey E. "Chance" Beebe was among the first three homesteaders on the west side of the North Fork of the Flathead River in 1908. Only twenty years old at the time, Chance reveled in the absence of close scrutiny by neighbors and officials and took advantage of the fact that the area was a hunter's and trapper's paradise.

He gained valuable experience in both hunting and trapping, as well as gained expertise in the geography of the northwest Montana frontier.[21]

On August 1, 1914, Chance Beebe married Eva V. DeFord in Columbia Falls, Montana. After living on Chance's homestead for a few years, in 1917, the married couple began working for Glacier National Park as a park ranger and ranger wife duo. Chance was a ranger from 1917 to 1920, and then began a long career as a government hunter, specializing in hunting mountain lions. During their time in Glacier Park, the young couple were stationed at the old Two Medicine, St. Mary, and Many Glacier ranger stations. The most detail about their lives as a ranger/ wife couple comes from their time at St. Mary in 1918–1919.[22, 23]

Life in the St. Mary ranger station included not only Chance and Eva, but two small children (Edward and Chauncey, Jr., born in 1915 and 1917, respectively). As was common up until the 1930s, ranger Chance worked twenty-four hours a day, seven days a week. Nonetheless, blurry photos of the family show they had time for recreation as well, including fishing, hiking, and ice skating on a frozen-over St. Mary Lake. Chance's patrol duties, in winter accomplished on showshoes or a dog sled, kept him away from the ranger station for extended periods, with Eva left to fend for herself and her small children.[24]

During the periods when Chance was away on patrol, life was not always easy nor safe for Eva and the children. Skunks often occupied the root cellar, and black bears took offense with flapping laundry drying outside and shredded it on the line. Most significantly, a mountain lion entered the attic through an upper window (as illustrated on the ranger station sign) and threatened Chauncey, Jr., in his crib. Eva's entrance into the room, in response to the child's crying, scared the lion off. Eva took the children, locked the door to prevent the lion from coming

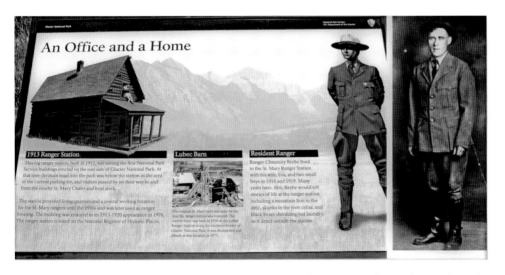

Left, photo display for the St. Mary Ranger Station cabin, Eva Beebe is discussed in the right-hand column. *Right*, Chance Beebe wearing one of the first new standardized National Park Service uniforms issued in 1920. (*Left, NPS; right, GNP GLACHPF#2681*)

Photo of the St. Mary Ranger Station where Chance and Eva Beebe and their children lived. (*Photo from Wikipedia, Creative Commons*)

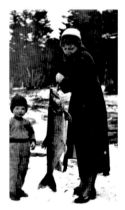 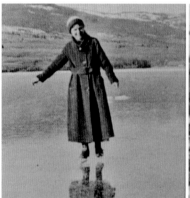

A montage of photos of Eva Beebe. *Left*, Eva and one of her sons admire the catch, probably from St. Mary Lake; *middle*, Eva Beebe ice skating on a frozen over St. Mary Lake; *right*, Eva on the way to her wedding in August 1914. (*Photos from Eva Beebe and Beebe family collection, contributed to GNP Archives*)

downstairs, and made the short walk to the nearby (now razed) St. Mary Chalets, run by the Great Northern Railway, for safety. After Chance returned from patrol, he and Eva returned to the cabin station and found it surrounded by mountain lion tracks. The upper window through which the lion had entered was sealed.[25]

The St. Mary Chalets served as refuge for the Beebes during the winter, and there Eva worked as a caretaker in return for a small salary and food. During the summer season, Ranger Chance would meet the Glacier Park Transportation Company buses at the chalets, and guide prominent visitors around the area. Well-known visitors included writer Mary Roberts Rinehart, conservationist George Byrd Grinnell, the president of the railway James J. Hill, and especially noteworthy, Queen Mary and Prince Albert of Belgium. The royal couple ate lunch with the Beebes, and Queen Mary gave Eva $5 to purchase candy for the children. The queen also spanked Chauncey, Jr., for sassing her.[26, 27]

Doris and Dan Huffine

Doris and Dan Huffine lived in and near Glacier National Park for decades, including living in East Glacier Park, running tourist camps first at Stanton Creek near the Nyack settlement and later at Essex near the Walton Ranger Station, and in later life in the Flathead valley. During their long association with the park region, husband Dan served as a temporary park ranger for several years and Doris lived the often-solitary life of a ranger's wife for the winter of 1927–1928.[28]

Dan Huffine served as a ranger, but was not classified as a permanent park ranger, from September 1926 to May 1928. Stationed first at St. Mary and staying in the same ranger station cabin as the Beebes had done several years before, he was eventually assigned to the Cut Bank Ranger Station in 1927. Dan met Doris Weaver, a young widow, in East Glacier in 1925, where he worked as a "gearjammer" (tourist bus driver) and she worked as a maid at Glacier Park Lodge. After initially disliking him rather intensely, Dan eventually won over the reluctant Doris such that they married on October 17, 1927. By the end of October, the newlyweds moved into the Cut Bank Ranger Station where they would spend the winter of 1927–28.[29]

After moving into the Cut Bank Ranger Station, Doris had to learn the life of a park ranger's wife. Particularly at the isolated Cut Bank station, this meant long periods without seeing another woman, as well as being in charge of running the household in the station while also helping Dan with his duties and patrols—all while adjusting to her newlywed status!

During the period from late October 1927, until May 31, 1928, the Huffines occupied the Cut Bank Station. Details of their life there, and some of Doris' adventures, are well described by John Fraley in his excellent book *A Woman's Way West*, from which the following information is extracted.

Doris' life as a ranger wife encompassed the usual domestic activities, including weekly attempts at baking bread (apparently not her strong point), sewing

 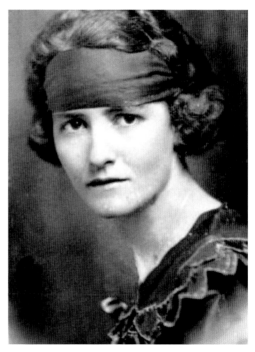

Photos of Doris Huffine. *Left,* photos on the cover of John Fraley's book about the life of Doris Huffine; *right,* photo of Doris Huffine. (*Left, author's personal collection; right, from findagrave.com*)

The Cut Bank valley, location of the Cut Bank Ranger Station where Doris Huffine and her ranger husband were stationed during the winter of 1927–28. (*Fred H. Kiser, OHSL ba020876*)

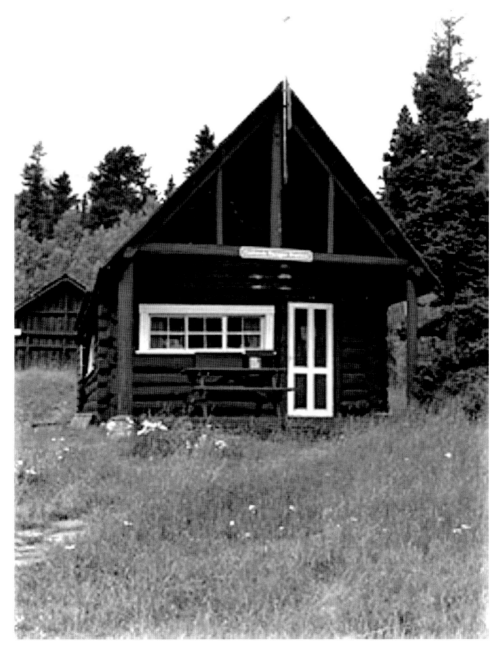

The Cut Bank Ranger Station, with barn/woodshed in the rear. (*Photo undated, National Register of Historic Places*)

and mending clothes for Dan, crocheting, embroidering and sewing, making a silk rug, making a beaded belt, and making moccasins. She also accompanied Dan on shorter patrols frequently, typically Dan on snowshoes and Doris on skis. When Dan was on longer patrols for periods of over two days, Doris endured the solitary loneliness induced by the isolated location of the Cut Bank station—it was 22 miles southward to East Glacier for mail pickup, and fifteen miles northward to St. Mary. In addition, Doris kept the ranger station daily log (park ranger stations began keeping regular logs the winter of 1927–1928), and often noted the harshness of the winter weather (high and persistent winds, and temperatures so cold that trees cracked and made gunshot-like sounds that scared her greatly the first time they occurred). She also noted wildlife abundance and signs of wildlife tracks around the station and in the Cut Bank valley.[30]

Two separate "adventures" in Doris' stay at Cut Bank ranger station stand out. The first was a trip to the St. Mary Ranger Station and Chalet for a Christmas visit. It was 9 miles from Cut Bank to the Hudson Bay Divide, and an additional 6 miles downhill to St. Mary. Dan wore snowshoes and Doris her usual skis. After reaching the Chalet well after dark, the Huffines spent Christmas day with the Chalet caretaker and his wife. The next day, Dan and Doris headed back to their station home. The grueling 6 miles uphill to the Hudson Bay Divide almost "did Doris in," and Dan had to vehemently cajole her to continue on for the final 9 miles back to the station, again arriving well after dark.[31]

The second adventure was a solo hike by Doris in May 1928 to Triple Divide Pass high above Medicine Grizzly Lake, a one-way distance of eight miles. Having done about two-thirds of this hike myself with three hiking companions in the summer of 1994, I can only marvel at the courage it took to embark solo on such a hike in the heart of grizzly country. Doris reached the pass in early afternoon, after the steep climb up from the trail junction with the trail to Medicine Grizzly Lake, crossing numerous areas where snow covered the steep climbing trail. After admiring the scenery, she retraced her steps back to the ranger station in time to make dinner, an amazing performance.[32]

Dan and Doris left the Cut Bank Ranger Station on the last day of May 1928, after Dan had found out that he would not be awarded permanent ranger status. The couple went on to numerous other adventures on the borders of Glacier Park, apart from the National Park Service. Doris' single season as a ranger's wife was nonetheless notable and to be marveled at.[33]

Marie and Clyde Fauley

Clyde Fauley was known as among the very best of the early Glacier Park rangers, and his wife Marie was a ranger's wife for many years. They met in the summer of 1922, when Clyde was working as a temporary ranger at the Belton (West Glacier) entrance station and Marie Fratzke was working as a waitress at

Clyde and Marie Fauley, from an article written by Clyde Fauley published in 1923. *Left*, captioned "Ranger Fauley in uniform" in his article. *Right*, captioned "The beauty of Shining Mountain is reflected in this pretty girl, who is Miss Marie Fratzke of Minnesota" in his article, photo taken at the Belton Chalet where Marie worked. (*Photos from Clyde Fauley 1923 article "Land of Shining Mountains", in magazine "Hunter-Trader-Trapper"*)

the nearby Belton Chalet. A Glacier Park summer romance led to their getting married in 1923.[34]

In the fall of 1923, Clyde was assigned to the now-razed Paola Ranger Station along the Middle Fork of the Flathead River, about 20 miles southeast of Belton and 10 miles north-northwest of Essex and the Walton Ranger Station. At the time, the only way to get to the station was via the Great Northern Railway, because U.S. Highway 2 had not yet been extended into the Middle Fork valley east of Belton. From the railway line, a cable or trolley bucket was used to cross over the Middle Fork into Glacier Park on the east shore. Due to the isolated location, Marie would not see another woman, or indeed another person other than Clyde, for months on end. Marie typically only crossed the river in the cable bucket to go to Kalispell to give birth and return to the ranger station (this occurred twice during their time at Paola). The couple left Paola in 1928, and later served at both the Two Medicine and Nyack Ranger Stations, the latter also along the Middle Fork and reachable only by a cable bucket. Marie was a classic ranger's wife, serving with little complaint at the isolated Paola and Nyack stations, but she preferred the Two Medicine station where the couple could live in town in nearby East Glacier Park and Marie could interact with neighbors.[35]

Alma and Frank Guardipee

Ethel Alma Kiernan, who went by Alma, was born outside of Missoula, Montana, in 1901. In the early 1920s, she worked for several summers at the now-razed Great Northern Railway's Going-to-the-Sun Chalets at what is now known as Sun Point. During this same time, a Blackfeet forester named Francis X. "Frank" Guardipee got to know Alma, and they married in 1929. In 1930, Frank became the first Native American ranger in Glacier National Park (and quite possibly the first in the entire National Park Service), and so Alma became a ranger's wife throughout the remainder of Frank's career, from which he retired in 1948 after which the couple moved to Browning on the Blackfeet Reservation.[36]

From 1930 until 1948, Alma and Frank lived in several Glacier Park ranger stations. Many summers were spent at the Two Medicine Ranger Station and winters at East Glacier. They also, however, were stationed at Nyack, Lake McDonald, East Glacier, and for two years in the mid-1930s at the North Fork Ranger Station (now gone) near the junction of the Middle and North Forks of the Flathead River, where both Frank and Alma interacted with members of a nearby Civilian Conservation Corps camp. Frank apparently enjoyed the isolation of the Nyack camp the best, but Alma preferred having neighbors at East Glacier.[37, 38]

During their years as a "ranger couple," Frank and therefore also Alma were on-call twenty-four hours a day, and because of the nature of being able to see fires, calls to the ranger station informing Frank of a forest fire he needed to rush out to and try to put out almost inevitably came at night. Frank would need to rush out to the fire site, leaving Alma alone at home for an unspecified period with their young son Frank "Gunner" Jr. Frank also patrolled extensively, again leaving Alma to tend the homestead. In an oral history recorded in 1984, Alma noted that Frank would never go anywhere without his .38-caliber pistol at his side because he had to be ready to pursue poachers at a moment's notice if he heard gunshots.[39]

Alma also described the difficulties associated with the Nyack Ranger Station cable bucket tram crossing of the Middle Fork of the Flathead River, similar to the one employed by the Fauleys at the Paola Ranger Station. She noted that one had to climb a ladder roughly 12 feet high to a platform, and then enter the 3 × 4-foot bucket suspended by cable over the river. To move, a handle clawed at the wire cable and worked one's way across the often-raging Middle Fork. Alma described the river as "terrible." She also recalled that one of the first things Frank did upon moving to Nyack was to try and tighten the cable, which subsequently broke, hit him in the head, and knocked him off the platform. Alma had to arrange to get Frank to the hospital in Kalispell as a result of this mishap.[40]

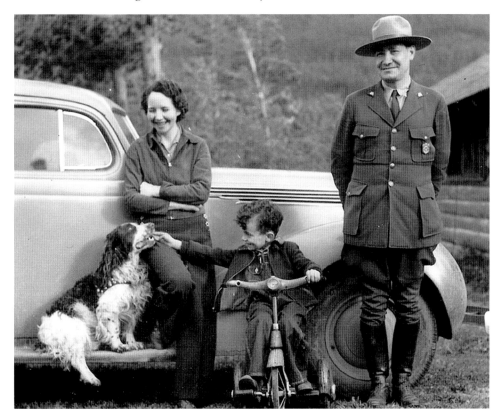

Alma Guardipee, with her husband Park Ranger Francis X. ("Frank") Guardipee and their son, Frank "Gunner" Jr., probably at the Lower Two Medicine Ranger Station (that station no longer exists) on the east side of Glacier Park. (*Undated photo from Ron Beard and GNP Archives*)

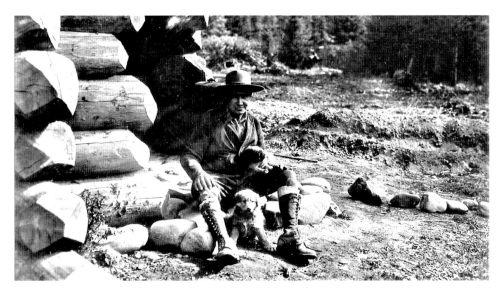

Frank Guardipee with puppies at the Nyack Ranger Station on the west side of Glacier Park along the Middle Fork of the Flathead River. (*Undated photo from Ron Beard and GNP Archives*)

Margaret and Elmer Ness

Among the more isolated ranger stations in Glacier Park, particularly in winter when it was completely cut off from automobile access, is the Belly River Ranger Station near the Canadian border. A ranger's wife in such a location had to endure isolation and the concern for her husband patrolling a very sparsely populated area of northeastern-most Glacier National Park. Margaret and Elmer Ness are representative of one such "ranger couple" that endured a frightening situation that illustrates the possible disastrous effects of such isolation.

In 1933, after packing in their complete supplies for the winter, Margaret and Elmer Ness became snowbound and would not be able to exit by auto again until May, 1934. On November 15, Elmer embarked on a typical multi-day patrol from Belly River, planning to go over Gable Pass to the Kennedy Creek (now the Otatso Creek) Ranger Station, from there to the Lee Creek Ranger Station in the very northeastern-most corner of the park, and eventually back to Belly River. He anticipated making it to the Kennedy Creek station in a day, so only packed a candy bar as a snack for his first day out.

> [Unfortunately] Park Ranger Elmer Ness was injured on November 15th when he slipped off the trail going over Gable Pass. He slid about 300 feet down the steep mountain side and unavoidably hit a large boulder at the bottom. He had gained such speed that the impact bounced him clear over the top of the rock which protruded about 4 feet above the snow. He sustained a splintered hip socket and a broken pelvis. It took him two days to reach the station after the accident. He will be in the hospital for several months, but doctors say he will recover.[41]

According to an oral history from Margaret Ness recorded in 1975, Elmer used his jackknife to cut two small pine trees to use as crutches, and with these he hobbled and crawled back to the Belly River Ranger Station over the course of two excruciating days, while also without food and exposed to the elements. Imagine Margaret's surprise and horror when Elmer appeared at the station in such a condition. She nursed Elmer for two weeks, but his pain became sufficiently great that the couple radioed to park headquarters, and the assistant chief ranger was able to make it to the station and evacuate the couple (details of how Elmer was carried out do not, unfortunately, exist). Elmer spent nearly four months in the hospital after being evacuated. Margaret's fortitude in dealing with this entire situation is remarkable, but not noted anywhere in the historical record.[42]

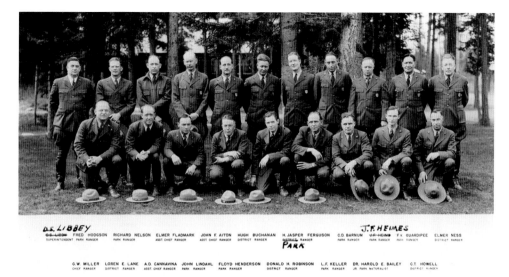

D.S. LIBBEY
D.S. LIBBEY FRED HODGSON RICHARD NELSON ELMER FLADMARK JOHN F. AITON HUGH BUCHANAN H. JASPER FERGUSON C.D. BARNUM J.F. HEIMS F.X. GUARDIPEE ELMER NESS
SUPERINTENDENT PARK RANGER PARK RANGER ASST CHIEF RANGER ASST CHIEF RANGER DISTRICT RANGER DISTRICT RANGER PARK RANGER PARK RANGER PARK RANGER DISTRICT RANGER

PARK

J.F. HEIMS

G.W. MILLER LOREN E. LANE A.D. CANNAVINA JOHN LINDAHL FLOYD HENDERSON DONALD H. ROBINSON L.F. KELLER DR. HAROLD E. BAILEY C.T. HOWELL
CHIEF RANGER DISTRICT RANGER ASST CHIEF RANGER PARK RANGER PARK RANGER DISTRICT RANGER PARK RANGER JR. PARK NATURALIST DISTRICT RANGER

Glacier National Park ranger force, April 22, 1941. Elmer Ness is in the back row at far right, next to Frank Guardipee. (*NPS*)

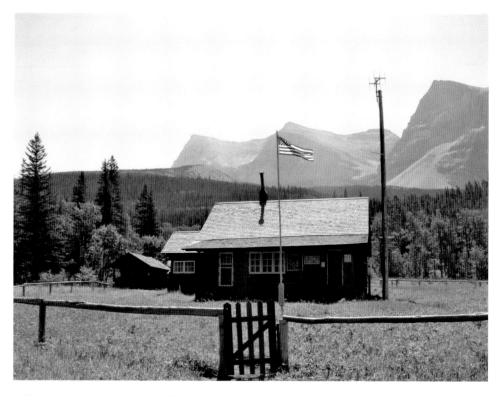

Belly River Ranger Station in far northern Glacier National Park, about 5 miles south of the U.S./Canadian border, where Margaret and Elmer Ness were stationed. View is southeastward to Gable Mountain at center. (*Photo by Jon J. Kedrowski, July 24, 2009*)

Mary Ellen and Glenn Miller

Probably the most isolated station in all of Glacier Park during this period was the Kishenehn Ranger Station at the far northwest end of the horrible Inside North Fork Road. That road has never been kept open in winter, so occupants are completely isolated for the duration of that season.

Mary Ellen and Ranger Glenn Miller were stationed at Kishenehn Ranger Station during the winter of 1935–36, during which they celebrated their first wedding anniversary. Often alone during the times Glenn made his multi-day patrol rounds, Mary Ellen enjoyed the solitary life at Kishenehn, remarking in an oral interview that she enjoyed snowshoeing and loved the peaceful calm of winter and the whiteness of the snow.[43]

Left, Kishehnen Ranger Station complex at north end of Inside North Fork Road as it existed in the 1930s (the road now ends at the turn-off for the Kintla Lake road). The ranger station was built in the 1920s. *Right*, Mary Ellen Miller, wife of Ranger Glenn Miller, shows off a coyote pelt shot by her husband while stationed at the Kishehnen Ranger Station in the winter of 1935–36. (*Left, George A. Grant photo, NPS; right, GNP Archives*)

4

Pioneering Women Authors of Glacier National Park

Visitors to Glacier Park began arriving soon after the Great Northern Railway came through northwestern Montana in the 1890s, and as we have seen, tourist facilities began popping up around Lake McDonald on the west side by the early 1900s. Great Northern-sponsored facilities blossomed in the decade of the 1910s on the park's east side in the form of hotels and chalets. Women came to both sides of the park, and several of the early female visitors wrote about their experiences and published books about their travels. Many of the early books about the scenic wonders of the park were written by women sponsored by the Great Northern Railway, and the books were designed to entice more visitors to take the train to the park and to take advantage of the railway's hotels and transportation offered by the railway's subsidiary companies in the park.

Helen Fitzgerald Sanders

The first descriptive visitor's book about part of what would become Glacier Park was written by a Montana resident who had become enamored of the landscape and ambience of the Lake McDonald region. Known best for her three-volume *History of Montana*, and as we have seen the author of *The White Quiver*, Helen Fitzgerald Sanders, a resident of Butte, Montana, began visiting the area in the 1900s. In her book *Trails through Western Woods*, she described her travels from Belton to Lake McDonald, up to the Sperry basin camp that now holds Sperry Chalet, and thence on to Sperry Glacier. She also ascended Lincoln Peak for its magnificent view of Lake Ellen Wilson and Lincoln Lake, as well as traveled up the McDonald valley and on to Avalanche Lake. A trip up the Inner North Fork Road to Lower Quartz Lake is also described in her book, which is illustrated by photographs taken by her.[1]

Sanders' book, largely forgotten today, caught the attention of famous environmentalist and writer John Muir, who praised her writing and the images

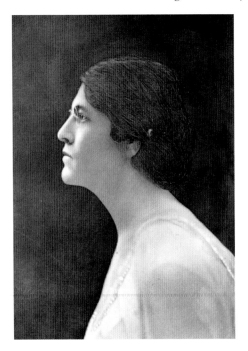 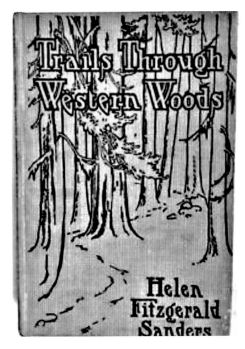

Above left: Portrait of Helen Fitzgerald Sanders. (*UMT, Maureen and Mike Mansfield Library, umt978.6 S215h v.1, photographer uncredited*)

Above right: One of Helen Fitzgerald Sanders' first books, *Trails through Western Woods*, published in 1910. (*Author's personal collection*)

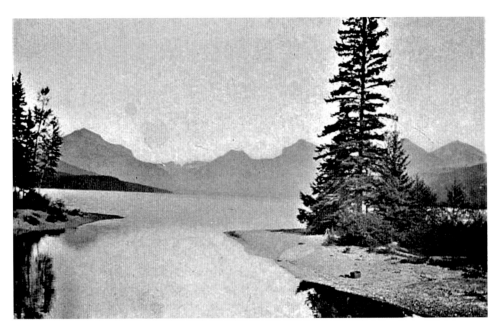

Photo of Lake McDonald at the outlet where McDonald Creek drains toward the Middle Fork of the Flathead River, from *Trails through Western Woods*. (*Helen Fitzgerald Sanders photo*)

of the region it evoked. In correspondence with Muir in 1911 after the book's 1910 publication, Sanders thanked him profusely for his kind words about her descriptions of the Lake McDonald area, and noted to him that she was "strangely devoted to the lake and its surrounding mountains." She noted to him that she felt compelled to visit the area year after year, and also described to him her visit over Gunsight Pass to the St. Mary Lake area in the summer of 1910. She said she considered Going-to-the-Sun Mountain the grandest peak of all.[2]

Mary Roberts Rinehart

Undoubtedly the most famous woman author to write about Glacier National Park was renowned mystery author Mary Roberts Rinehart, whose works were frequently compared favorably to the works of Agatha Christie. Rinehart wrote hundreds of works, but is best known for her mysteries. For our purpose, Rinehart is also remembered as the author of two travel books describing her adventures visiting Glacier National Park in 1915 and 1916.

Rinehart traveled westward from her home in Pennsylvania in 1915 to Glacier National Park, sponsored by the Great Northern Railway for the purpose of using a popular American writer to increase in the public mind the relationship between the railway, the Blackfeet Native Americans, and Glacier Park. Rinehart would take part in a 300-mile trip, over six mountain passes, on horseback over much of eastern Glacier Park with a large group led by western wrangler and guide Howard Eaton. She also was strongly impressed by the dignity and the suffering of the Blackfeet people she met, and subsequently became a spokesperson for their rights and economic plight in Washington, D.C. Her efforts on behalf of the Blackfeet people led to their adopting her into the tribe, and honoring her with the name Pitamakan, which had not been used since the days of the original "warrior woman" discussed in Chapter 1 of this book. Rinehart recognized the publicity benefits of her initiation of the tribe, and on July 22 wired to her publisher at Houghton Mifflin: "Adopted into Piegan or Blackfeet Indian tribe last night in powwow held at Cutbank Canyon Glacier Park. Given name 'Running Eagle' [Pitamakan] after famous warrior woman of the tribe."[3, 4, 5]

Rinehart enjoyed her Glacier Park experience with the Howard Eaton party (which included famous Cowboy Artist, Charlie Russell, who told campfire stories in the evenings) so much that she and her husband and three sons (her family members dubbed "The Head, The Big Boy, The Middle Boy, and The Little Boy" in her book *Tenting To-night*) planned an ambitious trip for the following summer in the remote northwestern part of the park. They first spent two weeks with another Howard Eaton party on the east side of the park, going over some of the same terrain as Mary had done the previous summer. After reaching Gunsight Pass, they then descended to Lake McDonald and on to Belton, where planning for the trip up the North Fork took place.[6]

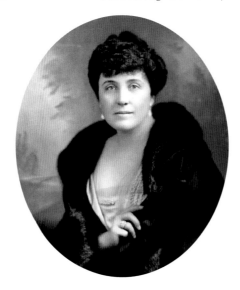

Two portraits of author Mary Roberts Rinehart. *Left*, undated photo; *right*, Rinehart in 1920. (*Left, photo by Granger; right, from George Grantham Bain collection, Library of Congress*)

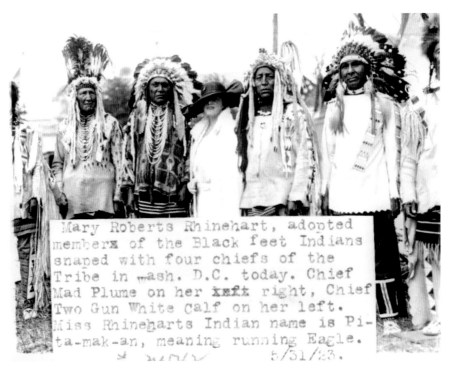

Mary Roberts Rinehart with four Blackfeet chiefs in Washington, D.C. Photo caption reads "Mary Roberts Rhinehart [*sic*.], adopted member of the Blackfeet Indians snaped [*sic*.] with four chiefs of the Tribe in Wash. D.C. today. Chief Mad Plume on her right, Chief Two Gun White Calf on her left. Miss Rhineharts Indian name is Pi-ta-mak-an, meaning running Eagle". (*Photographer uncredited, photo taken May 31, 1923. Library of Congress, Control Number 93508070*)

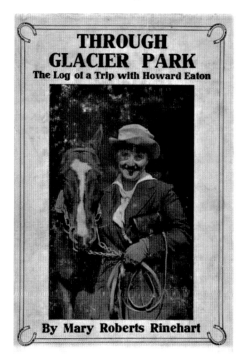
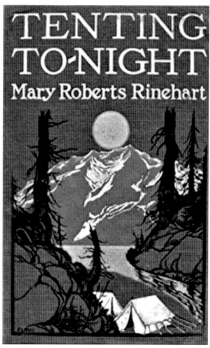

Mary Roberts Rinehart's two books on Glacier National Park, published in 1916 (left) and 1918 (right). (*Both from author's personal collection*)

Great Northern Railway brochure (*left*) containing a photo of, and an introduction written by, Mary Roberts Rinehart (*right*). The right-hand photo shows Rinehart in the field in the Cataract Creek valley by Grinnell Lake beneath Grinnell Glacier. (*Both photos undated, left uncredited, right by Fred Kiser*)

The Rinehart party and support group (which included wranglers, a cook, and a photographer) hauled boats up the Inside North Fork Road all the way to Kintla Lake, camping for several nights along the way. They subsequently "ran" the North Fork all the way to the junction with the Middle Fork of the Flathead, which they then followed as far as Columbia Falls, where they disembarked the river. Rinehart's book *Tenting To-night* provides great details about the trip and makes for fascinating reading. It was to be Rinehart's last trip to Glacier Park, but she subsequently wrote introductions for Great Northern Railway brochures about the park designed to entice more tourists to come visit the region and enhance the railroad's (and her) coffers.[7, 8, 9]

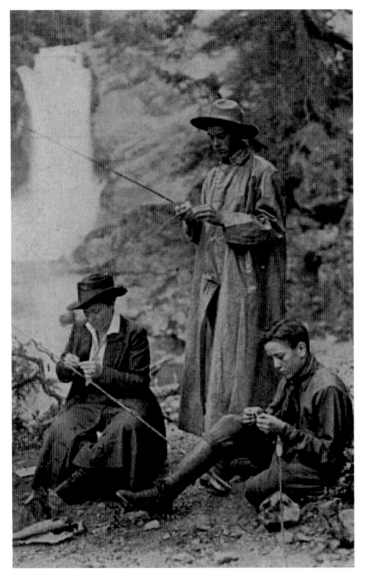

Mary Roberts Rinehart and two of her sons, fishing below Running Eagle Falls in the Two Medicine valley in Glacier Park. Photo is from her book *Tenting To-night*, and is labelled "The Author, the Middle Boy, and the Little Boy." Picture would have been taken during the two-week Howard Eaton-led part of their journey, prior to going "up the North Fork". (*Photographer unknown, public domain photo*)

Mary Roberts Rinehart and party lunching after trout fishing along the Middle Fork of the Flathead River. (*NPS, public domain photo, photo by Herford T. Cowling*)

Looking downvalley across Medicine Grizzly Lake in the Cut Bank valley, from her book *Through Glacier Park*. (*Photo by Mary Roberts Rinehart, 1915*)

Two views of Pumpelly's Pillar in the Two Medicine valley above Two Medicine Lake. *Left*, from *Through Glacier Park*; *right*, photo by author. (*Left, photo by Mary Roberts Rinehart, 1915; right, photo by author, August, 1981*)

Mathilde Edith Holtz and Katherine Isabel Bemis

Little biographical information is available on these two women, but bibliographic information reveals that they were educators in the Minneapolis area in the 1910s–1920s. Both wrote and compiled educational books for junior high-aged children, and it is likely that they were colleagues or at very least knew each other through their teaching and writing.

In 1917, the two women wrote a travelogue book *Glacier National Park: Its Trails and Treasures*, and it is noted on the interior title page that both were members of the American Rockies Alpine Club. The book is illustrated with a mix of photos taken by the authors, as well as by professional photographers who, although unattributed in the book, were in the employ of the Great Northern Railway including Fred Kiser and Roland Reed. The use of the Great Northern Railway photographers' photos suggests, in combination with the fact of the authors' homes in the Twin Cities area and also home of the Great Northern, that the railway may have sponsored the trip to Glacier.[10, 11]

Holtz and Bemis rode horses around much of the eastern part of Glacier Park, including the Mt. Henry/Scenic Point trail from East Glacier, Piegan Pass to Many

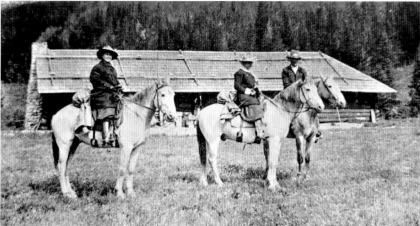

Left, photo of the 1917 book *Glacier National Park: Its Trails and Treasures* by Mathilde Edith Holtz and Katharine Isabel Bemis; *right*, photo of the authors and a wrangler from their book. (*Left, author's personal collection; right, unattributed photo following p. 58 in Holtz and Bemis book*)

Glacier, and from Lake McDonald to Sperry Glacier and thence over Gunsight Pass to Gunsight Lake where the authors waxed lyrical about the charms of the now-gone (destroyed by a snow avalanche in 1916) Gunsight Chalets. The authors also provided a number of interesting chapters on the Blackfeet tribe.[12]

Grace Flandrau

If Mary Roberts Rinehart was the most famous female author to write about Glacier Park in the early twentieth century, Grace Flandrau was very likely the second most renowned. A native of St. Paul, Minnesota, she wrote satirical fiction books and articles, and she was frequently compared favorably to fellow Minnesotan F. Scott Fitzgerald, in whose social circles Grace and her husband moved. In that same social circle were officers of the Great Northern Railway, including owner Louis Hill, and through these contacts Grace was hired for a two-year project to write historical pamphlets for the Great Northern. She was given a personal car and rail pass on the railway as well as the use of Louis Hill's caretaker's cabin in East Glacier for the duration of the project. She ultimately wrote eleven historical pamphlets including *The Story of Marias Pass*, the first such detailed history of the locating of the pass that gave the Great Northern a low-altitude passage over the Rocky Mountains. For many years afterwards, the railway made copies of this and her other pamphlets freely available to passengers on the railway.[13]

Two portraits of Grace Flandrau. *Left*, in "roaring 20s" style, photo taken in 1920; *right*, at a desk *circa* 1910. (*Photographers uncredited. Left, MNHS pf091949; right, MNHS 10325775.640x640*)

Agnes Laut

Agnes Laut, born in Canada in 1871, moved to the United States in 1900. She was a well-known writer and historian, writing novels and histories about both Canada and the American West. In her travels west, she became friends with Charlie and Nancy Russell. Laut carried on an active correspondence with Nancy Russell (copies of several of their letters are available online at the website of the Gilcrease Museum), and Charlie Russell provided illustrations for some of her books including *The Blazed Trail of the Old Frontier: Being the Log of the Upper Missouri Historical Expedition* (1926) done under the auspices of the Great Northern Railway. At the end of that trip described by Laut, the expedition was invited by Charlie and Nancy Russell to join them at Lake McDonald Lodge (then the Lewis Hotel) for a farewell and celebratory dinner.[14]

In 1926, Laut also published *Enchanted Trails of Glacier Park*. Although not explicitly noted that this book was sponsored by the Great Northern, virtually all the photographs in the book were provided by Great Northern-contracted photographers such as Fred Kiser and Roland Reed. Her book strongly praises the developments in the park built by the Great Northern, and also waxes lyrical about the artistry of her friend Charlie Russell. Overall, the book is a good "photograph in time" of Glacier Park and the state of its Great Northern-built developments in the mid-1920s.[15]

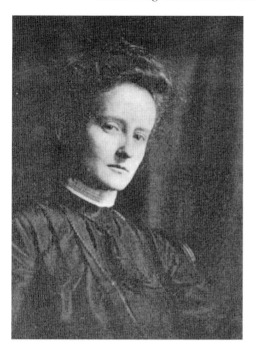

Two portraits of Agnes Laut. *Left*, Laut *circa* 1906; *right*, *circa* 1903. (*Both photos public domain. Left, uncredited; right, photo by William James Topley*)

Agnes Laut's 1926 book *Enchanted Trails of Glacier National Park*. (*Author's personal collection*)

Margaret Thompson

Margaret Thompson was a historian, teacher, and writer who became a school system superintendent later in her career. She wrote histories about aspects of the northwest, and in 1936 wrote *High Trails of Glacier National Park*. She visited the park in an unspecified year in the early/mid-1930s, from which she drew upon her knowledge gained for writing the book.[16]

Thompson's book heavily utilized photographs supplied by Great Northern photographers, including Roland Reed, Ted Marble, and Fred Kiser. The book also acknowledged the Great Northern for use of three color plates (two by artist Kathryn Leighton, discussed in Chapter 6) and the "Aeroplane Map of Glacier National Park, Montana, and Waterton Lakes National Park, Alberta" printed on the interior covers of the book. The book praised the development of the park done under the guidance of Louis Hill of the Great Northern. Thompson was impressed by the Blackfeet Native Americans she met in East Glacier, although her attitude concerning their well-being was maternal and patronizing (but probably typical of the time). Her book nonetheless offers insights into the nature of the park in the mid-1930s, and it is noteworthy that many of her travels in the park were done on foot rather than on horseback as had been typical in the 1910s and 1920s. Her book also was the first popular description of the completed Going-to-the-Sun Road, dedicated in July 1933. The book was very favorably reviewed in the *New York Times* on August 16, 1936.[17, 18]

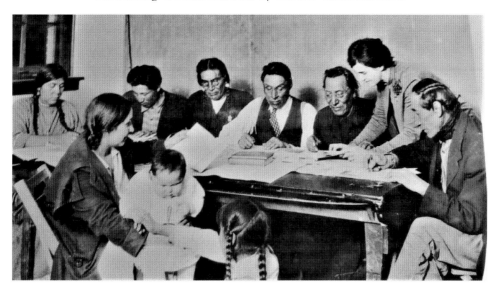

Above. Margaret Thompson, standing, teaching Blackfeet Native Americans to read and write. (*Photo by T.J. Hileman, circa 1930s, from Thompson's book* High Trails of Glacier National Park)

Below: *Left,* Margaret Thompson's book *High Trails of Glacier National Park; right, Ladder to Sperry Glacier* in Thompson's book. (*Left, author's personal collection; right, photo by R.E. "Ted" Marble*)

Influential Wives of
Early Glacier Park Artists

Influential women artists did not come to Glacier Park until the 1920s. Nonetheless, women were strongly involved in the early artistic legacy of the park through their influence and interactions with their important artist husbands. This chapter examines the influential roles of Nancy Russell, wife of the Cowboy Artist Charles M. "Charlie" Russell, and Carolyn Scheuerle, wife of Joe Scheuerle, artistic advertiser for the Great Northern Railway and creator of significant pieces of art recording Blackfeet Native Americans.

Nancy Russell

Charles M. Russell, Charlie to nearly everyone, is widely known as "the Cowboy Artist," judged by many to be the very best artist of western cowboy life America ever produced. It is a virtual certainty that his reputation would have been significantly less without the help of his wife, Nancy C. Russell. Nancy Russell served as Charlie's biggest fan, but also his business manager and promoter. Her efforts spread Charlie Russell's western art across the country and overseas, and secured his place in artistic history. Much of that history is tied in with Glacier National Park, where the Russells spent their summers on Lake McDonald.

Nancy Russell's drive in support of her husband came from her hard-scrabble background, growing up poor in rural Kentucky. Born there in 1878, she moved with her family to Montana in 1890 in search of a better life associated with mining opportunities there. Her father went off to mines in Idaho and was a non-factor in her life from then on. After her mother's death in 1895, Nancy took a job in Cascade, Montana, with Mr. and Mrs. Ben Roberts. They in turn introduced her to the Cowboy Artist, Charlie Russell, in 1895. He was immediately smitten by Nancy, and they married on September 9, 1896. After living a year in Cascade,

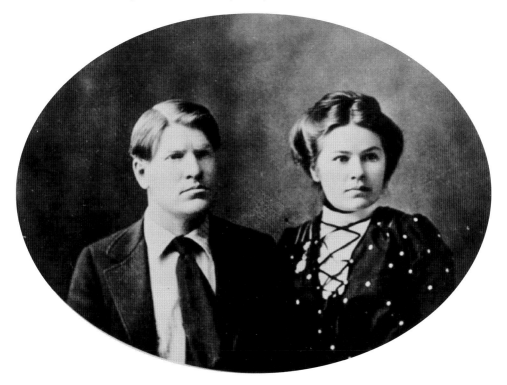

The wedding photo of Charlie and Nancy Russell in 1896. (*TU TU2009.39, photographer unattributed*)

Drawing by Charlie Russell depicting the effects of married life on him and his surroundings. *Left*, As I Was; *right*, As I Am Now. (*Undated but post 1896 wedding, both drawings by C.M. Russell; left, MHS Museum 1986.06.04; right, MHS Museum 1986.06.05*)

the Russells moved to Great Falls, where they built their home and eventually a studio, and lived until Charlie's death in 1926.[1,2]

Nancy and Charlie Russell's long-time association with Glacier National Park began in 1904 and 1905, when they spent summers on the shore of Lake McDonald. Having fallen in love with the location for its scenery and for the inspiration it gave to Charlie's art, the Russells had a cabin built across the lake from Apgar on a plot of land sold them by Apgar settler Dimon Apgar. The cabin became known after a year or two as Bull Head Lodge, so named for Charlie Russell's signature bison skull with which he adorned almost all his paintings. The Russells' cabin was largely hidden from view from the lakeshore, but Charlie placed a large, bleached bison skull on the wall of the cabin facing the lake so that visitors arriving by boat (the only way in early years to reach the site) could spot the skull through the trees and make their way to the lodge. Charlie and Nancy spent virtually every summer there until his death, and Nancy continued to spend most summers there until her passing in 1940.[3,4]

At Bull Head Lodge, the Russells frequently entertained friends and visiting artists and writers, including writer Agnes Laut and artists Kathryn Woodman Leighton and Joe Scheuerle. Charlie loved to tell stories in the evenings, sometimes telling a story about the Blackfeet solely by using the sign language of the Piegans, which Nancy would interpret for their visitors. Charlie had a gazebo and a studio built at the lodge after a few years, but he also loved to paint *plein air*. The Russells would often row across Lake McDonald to the Lewis Hotel (now Lake McDonald Lodge) for dinner, where they would be announced to the other dinner guests because of Charlie's fame. Charlie's work was also displayed prominently on the walls of the lodge and dining room, which pleased Nancy greatly because

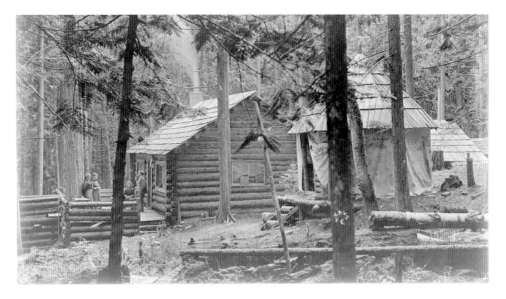

The Russell's log home dubbed Bull Head Lodge, near the shore of Lake McDonald, 1913. In the photo, *left to right*, are Nancy Russell, Josephine Trigg of Great Falls, Isabel Russell of St. Louis, and Charlie Russell (*MHS umt016924, photo by A.J. Thiri*)

View from Apgar towards the lakeshore of Lake McDonald where Bull Head Lodge hides in the trees behind the lakefront cabins. (*Photo by author, taken October 17, 2007*)

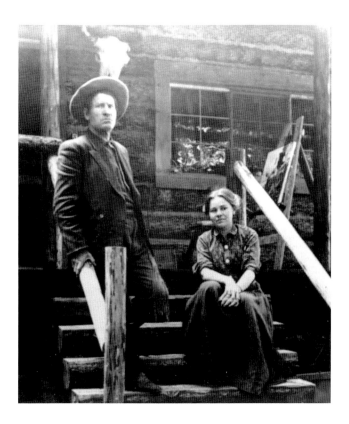

Charlie and Nancy Russell on the steps of Bull Head Lodge. The "bull head" bison skull after which the lodge is named is mostly visible behind Charlie's hat. (*CMRM, undated, photographer unattributed*)

Charlie and Nancy Russell in a somewhat formal pose on the deck of Bull Head Lodge. (*TU TU2009.39.272.2C_06, undated, photographer unattributed*)

Charlie and Nancy Russell in the woods around Bull Head Lodge. (*TU TU2009.39.257.16b, undated, photographer unattributed*)

Charlie and Nancy Russell in the woods near Bull Head Lodge in 1910. This view clearly shows the sash Charlie wore rather than a belt. (*TU, photographer unattributed*)

Charlie and Nancy Russell in the woods around Bull Head Lodge. (*TU TU2009.39.272.3A, undated, photographer unattributed*)

Nancy Russell sitting on the steps of Bull Head Lodge. (*TU TU2009.39.5986B, undated, photographer unattributed*)

of the exposure of Charlie's art to wealthy patrons of the hotel. Charlie often gave his sign language presentations to the other diners which Nancy would interpret, and Nancy used such opportunities to find markets for his work among the diners at the hotel, as well as with other landholders around Lake McDonald, and across the country and in Europe. Charlie recognized Nancy's business acumen and attributed all his financial success to her handling of his affairs.[5,6,7]

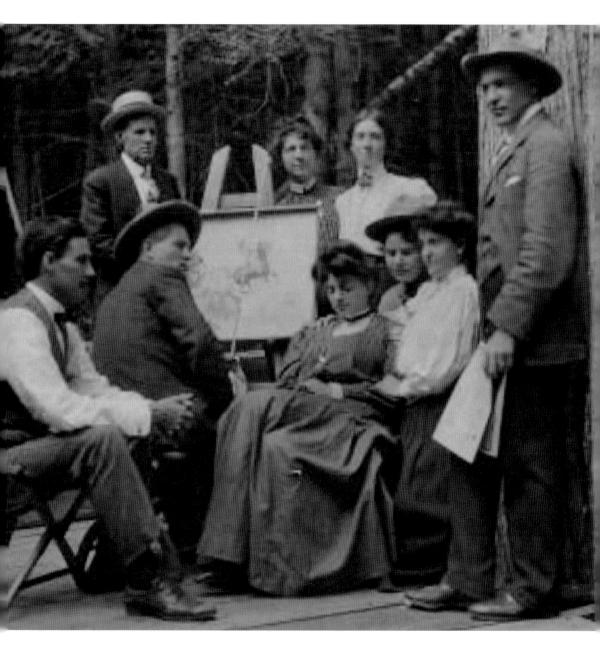

Charlie Russell painting on the porch of Bull Head Lodge surrounded by friends, Nancy Russell sits wearing a hat, 1906. (*Amon Carter Museum of American Art, undated, unattributed*)

Elk in Lake McDonald, 1906. (*Charles M. Russell painting, public domain*)

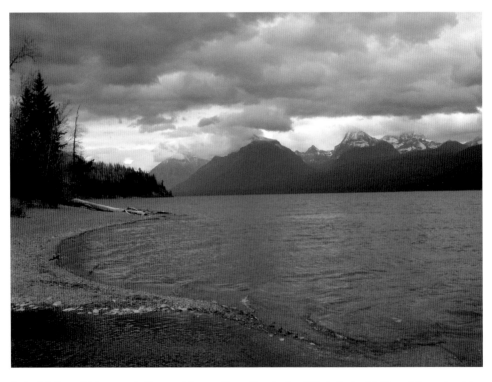

Lake McDonald from a similar position to Russell painting *Elk in Lake McDonald*, on the delta of Fish Creek. (*Photo by author, taken October 18, 2007*)

As we saw in the discussion of Mary Roberts Rinehart last chapter, dude wrangler Howard Eaton would feature prominent individuals as guests on his three-week-long horse excursions over six mountain passes (Dawson, Pitamakan, Triple Divide, Piegan, Swiftcurrent, and Gunsight), covering roughly 300 miles from East Glacier to the final destination at Lake McDonald. In 1915, Eaton featured Charlie Russell as the campfire storyteller, no doubt assisted by Nancy during sign-language presentations. Nancy also saw an opportunity to "work the crowd" of wealthy "dudes," encouraging them to purchase Charlie's art to take home as a significant memento of their time in Glacier Park. Nancy was determined to never again live in the poverty she remembered from her childhood and youth, and that determination made her such a successful businesswoman and purveyor of her husband's art. After Charlie's passing in 1926, she spent the remainder of her years doing everything she could to ensure that her husband's artistic legacy would be forever remembered.[8, 9]

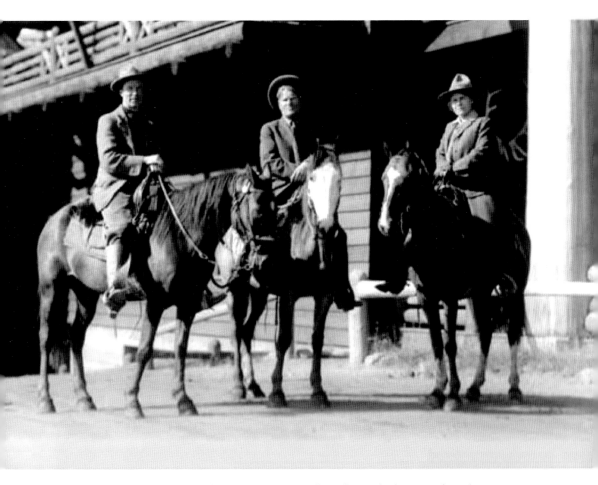

Artist John Young-Hunter, Charlie and Nancy Russell, in front of Glacier Park Lodge in East Glacier, before heading out with Howard Eaton's 300-mile trip in Glacier National Park, 1915. (*CMRM CMR 11 Big Sky Collection, Almeron J. Baker photo*)

Above: Nancy Russell at her home desk in Great Falls, Montana. (*MHS Photograph Archives PAc-2000-40.23, circa 1917, A.J. Thiri photo*)

Below: Nancy Russell in Charlie Russell's studio in Great Falls, Montana. (*TU TU2009.39.7654.18, circa 1908, photo unattributed*)

A pensive Nancy Russell on the shore of Lake McDonald. (*TU TU2009.39.6001, circa 1906, photo unattributed*)

Carolyn Scheuerle

Carolyn and Joe Scheuerle were among the artistic friends who frequently visited the Russells at Bull Head Lodge and elsewhere. Carolyn's role was not as immediately prominent in Joe Scheuerle's success as an artist as was Nancy Russell's with Charlie, but it was significant nonetheless.

Joe Scheuerle was an artist who as a child growing up in Austria was captivated by the American Wild West and Native Americans. After his family immigrated to the U.S. and settled in Cincinnati in 1882, Scheuerle eventually studied art at the Art Academy of Cincinnati, from which he graduated in 1896. He moved to Chicago in 1900 and was employed as a lithographer, drawing posters for wild west shows and drawing portraits of Native Americans in those shows. In Chicago, he met Carolyn Lohrey, and they married in 1904. Their daughter, Margaret, was born in 1906. Carolyn became Joe's traveling companion for over thirty years of subsequent trips out west, with Carolyn described as Joe's "constant companion" on his trips westward. Evidence of Carolyn and Joe's inseparability is shown in travel photographs of the two, several of which are reproduced here.[10, 11]

In 1910, Joe and Carolyn began a long-term association with Glacier National Park, when Joe was hired by Great Northern Railway president Louis Hill to create promotional materials for the new national park that Hill could use in his "See America First" advertising campaign. Hill also encouraged Joe to create portraits of Blackfeet Native Americans that Hill could also use in his campaign

to tie in the public's mind the Blackfeet with Glacier National Park. Joe provided drawings for the covers of Great Northern booklets/pamphlets touting a visit to Glacier Park, and also created caricature postcards of tourists (modeled after Carolyn and himself?) in humorous situations in the park.[12, 13]

In Glacier Park, the Scheuerles were introduced to Charlie and Nancy Russell, and a long-term friendship developed among the four that continued after Charlie's passing. The Scheuerles were frequent guests at Bull Head Lodge, and both Joe and Carolyn (whom Joe called "Cal") engaged in a rich correspondence with Charlie and Nancy Russell that is preserved in archives, especially at the Gilcrease Museum of the University of Tulsa.[14, 15.]

During their frequent trips to Glacier, the Scheuerles made extensive trips across the park landscape. These trips involved extensive horseback riding as well as hiking up steep slopes, both notable accomplishments for Carolyn in the heavy skirts of the period. She did not shy away from an adventurous outing, and she and later also daughter Margaret continued to support Joe on his western travels through his final trip west in 1938. No biography of Carolyn Scheuerle exists, but she is surely worthy of one; surely Joe Scheuerle's considerable association with Glacier Park as well as with the Russells would have been far less rich without Carolyn's constant presence and support.

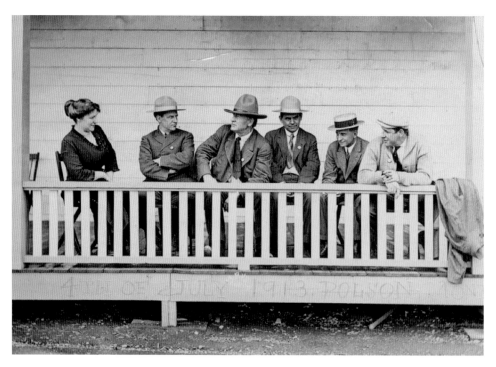

At the Fourth of July celebration in Polson, Montana, 1913. *Left to right*, Carolyn Scheuerle, William Krieghoff, Cowboy Artist Charles M. Russell, Joe Scheuerle, unknown, and person labelled as "Hop". (*MHS p0000019, photographer unknown*)

Scheuerle family Christmas card, 1914, annotated "Regards from Big Chief & family". Although politically incorrect today, the Scheuerles had extensive experience with and respect for Native American tribes and advocated for their well-being. (*MHS p0002887, photographer unknown*)

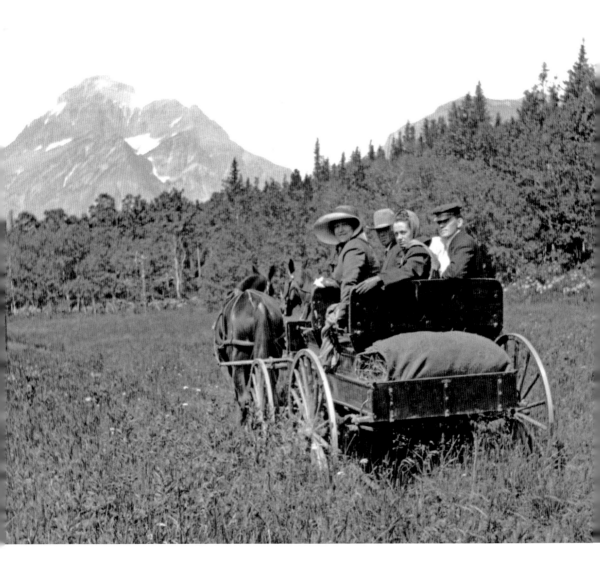

The Scheuerles on glaciers in Glacier Park. Left, Carolyn (*far right*) and Joe (*middle*) Scheuerle hiking with friends on Sperry Glacier, *circa* 1910–1919. *Right*, Joe Scheuerle (*left*) and Carolyn Scheuerle (*second from left in large hat*) with two unidentified men and an unidentified woman traversing an unspecified glacier in Glacier Park. (*Left, MHS p0002903, photographer unknown; right, MHS p0002900, circa 1910-1919, photographer unknown*)

Opposite above: Left, Carolyn and Joe Scheuerle on horseback, probably in Glacier Park, *circa* 1919. *Right*, cartoon drawn by Joe Scheuerle advertising horseback rides in the park for the Great Northern Railway. The caricatures look rather like the Scheuerles in the adjacent photo. (*Left, MHS p0002903, photographer unknown; right, MHS Museum Collections Online 20177507*)

Opposite below: Wagon ride in the Two Medicine valley in southeastern Glacier Park. Carolyn Scheuerle is the large-hatted woman on the left. Rising Wolf Mountain dominates the left distance. (*MHS p0002898, date and photographer unknown but likely photographed by Joe Scheuerle*)

Guest register screen for 1914, at the Bull Head Lodge, Montana. Note the names "Joe Scheuerle", and beneath it "Cal" and a ditto mark, indicating Cal Scheuerle (Joe's nickname for Carolyn). (*TU TU2009.39.5921a-b, 1914, photographer unattributed*)

6

Pioneering Women Artists of Glacier National Park

The magnificent scenery of Glacier Park has inspired artists since people first began visiting there. Portraying the dignity of the Blackfeet Native Americans living along the eastern border of the park also was a focus for many early artists. Early women artists were heavily involved in both areas, painting the landscape *plein air* (experiencing and painting in the landscape rather than in the studio) and also painting Blackfeet portraits both in the studio and on site. Unfortunately, very little attention has been given early women artists in Glacier Park in otherwise excellent historical coverages of artists working there. Peterson's excellent history of the artists of the park does provide a photo and a painting by Elizabeth Lochrie and also by Elsa Jemne, and a painting by Kathryn Leighton, but no text material (only figure captions) is given them.[1]

Fortunately, the good people of the Hockaday Museum of Art in Kalispell, Montana, whose mission is to "preserve the art of Montana and Glacier National Park," recognized the disparity in coverage of early as well as recent female artists involved in painting Glacier National Park as well as Blackfeet Native Americans. In 2015, the museum staged an exhibition of women artists and published a book as well as a PBS documentary film about the exhibition that finally gives several early women artists in Glacier Park their due moment in the spotlight. The following descriptions of these pioneering female artists are derived from that exhibition book unless otherwise noted.[2]

Nellie A. Knopf

Nellie Augusta Knopf, born in Chicago in 1875, studied at the Art Institute of Chicago and in 1900 joined the faculty of the Illinois Women's College (now MacMurray College), where she taught for forty-three years, eventually becoming director of the art department. She also received a doctorate from the college in 1905.

Two photos of Nellie Augusta Knopf. (*Left, photo by Angie Dunfee; right, worthpoint.com, photographer unknown*)

Painting of Iceberg Lake. (*Photo of Nellie Knopf painting, Montana PBS*)

Mountain Landscape, oil on board, by Nellie Knopf was based on the view of Appekunny Mountain seen from the hill behind the Many Glacier Hotel near the old men's dormitory. (*Left, photo of 'Mountain Landscape' by Nellie Knopf, artnet.com; right, Appekunny Mountain, photo by author, July 30, 2000*)

Short of stature, square of figure, and hearing impaired, Nellie was keenly aware of discrimination as well as limitations society attempted to put upon people of her gender. Women artists of the period were expected to draw and paint fruit and/or flowers with watercolors, safely indoors. Nellie would have none of that. In order to avoid discrimination of her work and the outdoors landscapes she painted, she signed her work as "N.A. Knopf". She drove across the west seeking locations to paint, and in the summers of 1925 and 1926 found the scenery of Glacier National Park to her liking, one of the first women to paint there. Critics found her Glacier Park landscape works in oil to be colorful, bold, and very vivid. She painted for fifty years and passed away in 1962.

Kathryn Leighton

Kathryn Woodman was born in 1875 in Plainfield, New Hampshire. She studied art in Boston and graduated in 1900, the same year she also married Edward Leighton. The couple moved to Los Angeles in 1910, and at a party there was introduced to the Cowboy Artist, Charlie Russell. Kathryn and Charlie became good friends, and the Leightons began visiting Bull Head Lodge at Russell's invitation. They enjoyed Glacier Park sufficiently that they rented a cabin on Lake McDonald in the summer of 1925 and Kathryn began painting panoramas of landscapes in the park.

With Charlie Russell's recommendation, Kathryn Leighton contacted officials of the Great Northern Railway as well as officials of the Blackfeet Nation, and in 1926, she received a commission from the railroad to paint Blackfeet elders as

part of the well-documented campaign of the railway to imprint in the public's mind the association between the Blackfeet and Glacier National Park. The railroad provided Leighton and her family three months of lodging in the park and facilitated her meetings with Blackfeet whom she painted. The Blackfeet and the railroad were impressed by her paintings—the railroad paid high prices for twenty of the paintings, which were sent on a cross-country tour, and the Blackfeet adopted Leighton into their tribe. They gave her the name "Anna-Tar-Kee," meaning Beautiful Woman in Spirit. Leighton toured Europe and the eastern United States with her paintings, and was well celebrated and recognized for her artistic skills. She passed away in 1952.

Above left: Portrait of Kathryn Leighton. (*Vose Galleries, Boston, MA, photographer unattributed*)

Above right: Self Portrait of the Artist Seated at a Table, self-portrait by Kathryn Leighton. (*Unattributed photo of Kathryn Leighton painting, artnet.com*)

Grinnell Glacier by Kathryn Leighton, perhaps her most well-known painting. (*Photo from Summer 2015 issue, Big Sky Journal*)

Swiftcurrent Lake by Kathryn Leighton. (*Photo from askart.com*)

Elsa Jemne

Elsa Jemne was born Elsa Laubach in July 1887 in St. Paul, Minnesota. She studied art in St. Paul and Philadelphia, and won an award to study art in Europe. She went to Italy in 1914 to study frescoes, but was forced to remain in place for a time because of the outbreak of World War I. After returning to St. Paul in 1917, she married architect Magnus Jemne and the couple settled in St. Paul.

Jemne became well known for painting murals in public buildings in the upper Midwest, and in 1925 and 1926 was invited by Great Northern Railway President Ralph Budd to spend two months each summer painting portraits of the Blackfeet. She lived in a large teepee among the Blackfeet, and several of her portraits were painted in the teepee. Jemne also painted landscapes of Glacier Park while in the area. The Blackfeet came to appreciate Jemne's independence and willingness to live among them, and she was adopted into the tribe in a ceremony in Fort Union, Montana. Jemne subsequently was a teacher in the 1930s and 1940s at the Minnesota School of Art. She worked on commissioned public building murals under the sponsorship of the W.P.A. in the 1930s, and focused more on her palette painting after that period. Jemne died in 1974, leaving a strong legacy of art associated with both Glacier National Park and especially the Blackfeet people.

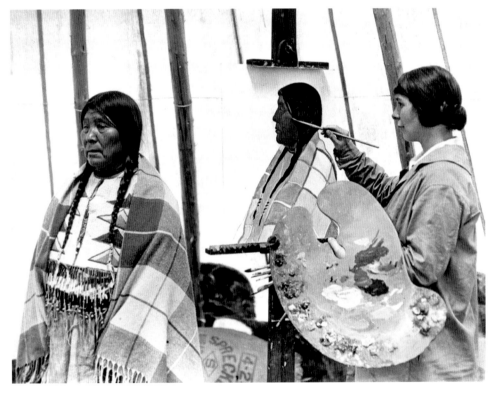

Elsa Jemne painting Mrs. Curley Bear in Jemne's teepee, 1926. *(Photo by T.J. Hileman, MNHS N1.1 p146)*

Above: Untitled (Glacier Park), watercolor on paper by Elsa Jemne, *circa* 1926. (*MNHS, mnopedia.org/ multimedia/untitled-glacier-park*)

Right: Yellow Kidney, Keeper of the Beaver Bundle, painting by Elsa Jemne, 1926. (*MHS Collection X1965.19.0*)

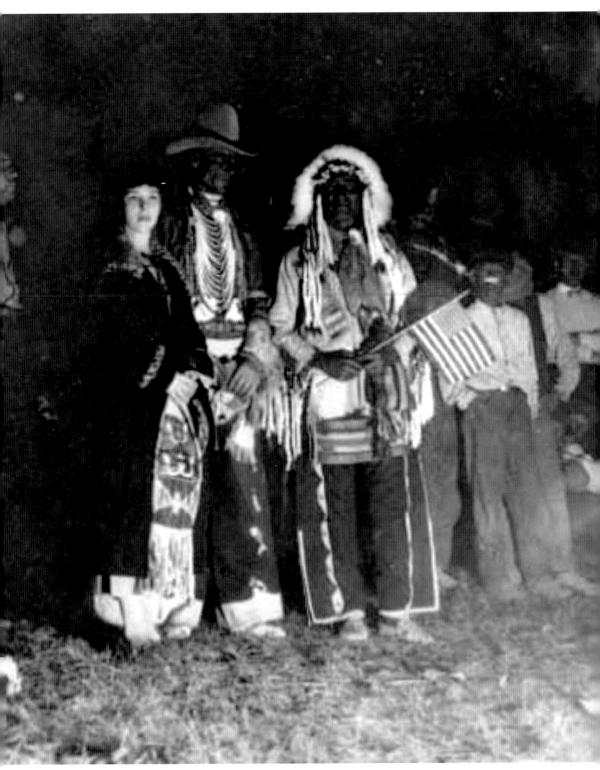

Elsa Jemne being adopted into the Blackfeet Tribe in Fort Union, MT. (*Photographer unknown, photo undated, MNHS por 11503 p2*)

Elizabeth Davey Lochrie

Elizabeth Davey was born in July 1890 in Deer Lodge, Montana, the only early women artist pioneer actually born in Montana. She studied art at the Pratt Institute in Brooklyn, New York, after which she returned to Deer Lodge and embarked on her career as an artist. She married local banker Arthur J. Lochrie in 1913, and they were married for sixty-two years. In 1923, she received a commission from the state of Montana to paint a series of murals in a new children's wing of the State Tuberculosis Sanatorium in Galen, about 10 miles from Deer Lodge. In 1928, the Lochries moved to Helena, where they continued to live for over forty years. In the 1930s, Elizabeth carried out a series of commissioned murals in post offices in Montana and Idaho.[3, 4]

Elizabeth traveled by herself around the west in search of landscapes to paint, and in 1931 made a trip to Glacier National Park. She returned annually to the park for many years, and in 1933 and 1934 studied with renowned park painter Winold Reiss at his school on the shore of St. Mary Lake. Lochrie painted well-received landscapes from locations across the west including Glacier Park.[5]

During her travels to Glacier Park, Lochrie became friends with Gypsy Bull Child, a Blackfeet woman she met in 1931 while sketching near the teepees of a Blackfeet encampment near the Many Glacier Hotel. Their friendship grew, and in the summer of 1932, Elizabeth returned to Glacier Park Station where she rented a cabin. The Bull Childs adopted her into their family and the Blackfeet, giving her

Photo of Elizabeth Davey Lochrie. (*Unknown date and photographer, Hockaday Museum of Art*)

Hand-painted and handmade Christmas card by Elizabeth Lochrie. (*Elizabeth Davey Lochrie Christmas card to W. Langdon Kihn, after 1931. W. Langdon Kihn papers, 1904-1990. Archives of American Art, Smithsonian Institution*)

Elizabeth Lochrie painting, oil on Masonite, of Going-to-the-Sun Mountain in Glacier Park. (*MHS 1979.12.136*)

Heavy Breast—Blackfoot, oil on
canvas painting by Elizabeth Lochrie,
1934. (*MHS 1979.12.105*)

the name "Net-chi-ta-ki," meaning Lone Woman, or Woman Who Came Alone.
Her adoption allowed Lochrie to paint among the Blackfeet, and her portraits
of them are highly prized. She learned the Blackfeet language and sign language,
becoming a spokesperson and knowledgeable lecturer on behalf of their welfare.
Lochrie continued to paint well into her eighties and passed away in 1981.[6, 7]

Leah Dewey Leabo

Leah Dewey, born in Fairmont, Nebraska, in 1896, studied art and design at
Columbia University in New York and moved to Great Falls, Montana in 1925.
There, working in a jewelry store, she eventually met and married jeweler Hjalmar
Leabo in 1937. The Leabos settled in Missoula, and Leah Leabo became an
important sketch artist and painter of western mountains. Leabo was chosen as
one of two artists whose work was chosen to represent the state of Montana at
the Second National Exhibition of American Art, in New York City in 1937.[8]

Lucile Van Slyck

Wilma Lucile Van Slyck, usually known as Lucile Van Slyck, was born in Cincinnati,
Ohio, in 1898 and spent summers in Montana as a teenager. She was trained at
the Cincinnati Art Academy and later at the National Academy of Design in New
York City. She is regarded by the Hockday Museum of Art as the archetype of the
fearless early female artists who came to Glacier Park, and a stylized image of her
is used by the museum as their symbol for their annual exhibition, that began in

Left: Leah Dewey Leabo. (*Hockaday Museum of Art, photographer unknown*)

Below: High Country (Highwoods east of Great Falls) by Leah Dewey Leabo. Although not a painting of Glacier Park, this oil on canvas painting reveals Leabo's adept hand at portraying mountain landscapes. (*MHS X1981.01.27*)

Right: Portrait photo of Lucile Van Slyck. (*Undated, unknown photographer, MHS Research Center Photographic Archives*)

Below left: Inspiration, Van Slyck in Glacier Park, April, 1929, although most sources cite this trip as occurring in 1930, shows Lucile Van Slyck engaged in *plein air* painting in Glacier Park. (*Unknown photographer, umtp0003329*)

Below right: Photo of Lucile Van Slyck, titled *Tenderfoot Dude and Thrilled to Be Here*, on the *Trail with Forty-five Pound Pack, Spring, 1928.* (*Unknown photographer, MHS _PAC 93-28*)

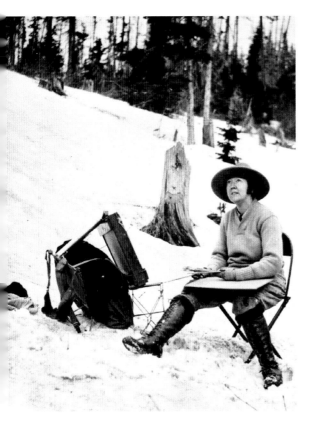

2015, of women park artists. Painting mountain landscapes as well as portraits of the Blackfeet, she made a solo trip carrying a 45-lb pack into the park in April, 1930. She set up camp in the Many Glacier region and proceeded to paint *plein air*, to the astonishment of the Park Superintendent who dispatched a park ranger to determine if Lucile needed help. The ranger was assured that all was well, and that she was there to see the snow contrasted with the dark Spring waters as the ice began to melt. Her work with the Blackfeet led to their adopting her into the tribe, giving her the Blackfeet name "Ko-ko-me-kee-sum," meaning Princess Moonlight Woman. Van Slyck was married twice and died in 1982. She truly represents the concept of a pioneering woman artist in Glacier Park.[9]

Opposite above: My Camp at Sprague Creek, on the shore of Lake McDonald near Lake McDonald Lodge. (*Collection of Julie Moffitt and Jim Strainer, undated, Hockaday Museum of Art*)

Opposite below: Landscape by Lucile Van Slyck, oil on panel, showing the Grinnell Glacier cirque above Grinnell Lake. (*From askart.com*)

Pioneer Outdoorswomen of Glacier National Park

The early days of Glacier National Park were dominated by hikers, horseback riders, and climbers. Perhaps surprising to some, many of these early outdoors aficionados were women. This chapter examines examples from each of the categories of outdoor activity mentioned at the beginning of this chapter.

The 1914 Visit of the Mountaineers of Seattle

Few people arrived at Glacier National Park by car in the 1910s. Nearly every visitor arrived via the Great Northern Railway, at either the Glacier Park (East Glacier) or Belton (West Glacier) stations. This method of arrival ensured that those visitors either walked/hiked their way around the park or rode horseback. The Mountaineers of Seattle's visit in 1914 is representative of such an arrival and exploration of the park.

The Mountaineers arrived at Glacier Park Station on August 2, 1914, and proceeded to embark on an ambitious hiking exploration of a broad swath of Glacier Park. Fully 115 people comprised the group, and approximately half of that number were women. These women hikers wore full-length skirts, long-sleeve blouses, and floppy sunhats, but they hiked right alongside their male companions. The men of the group camped the entire trip, whereas the women usually also camped but were offered indoor bedding by Louis Hill of the Great Northern Railway at the Gunsight Chalets. The ambitious itinerary of the large group led from East Glacier over Scenic Point to Two Medicine, from there over Dawson Pass and into the Nyack Creek valley, and on to and up over the now long-abandoned Red Eagle Pass trail eventually to reach Gunsight Lake. From there, the group progressed over Piegan Pass to the Swiftcurrent valley, and eventually over Swiftcurrent Pass to the Highline Trail near Granite Park Chalet. Northward from there, the party explored up to the Waterton valley near the base of Mt. Cleveland, and eventually back to Flattop Mountain and down the

Great Northern Railway brochure designed to appeal to women as potential hiking visitors, *circa* 1915. Landscape appears to be an idealized view of the Grinnell Glacier cirque. (*GNR*)

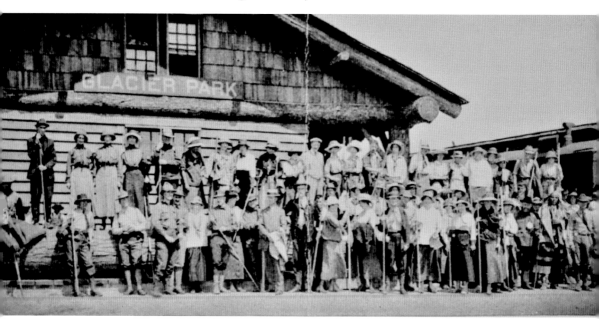

Photo of the Mountaineers of Seattle at Glacier Park Station (East Glacier) in a 1916 Great Northern Railway brochure encouraging visitors to come for the hotels and tours of Glacier Park. Note that half or more of the group are women. (*Unknown photographer, GNR*)

McDonald Creek valley to Lake McDonald and on to Belton. Side trips to glaciers were frequently taken along the way, including to Red Eagle and Chaney glaciers. This was an extended, multi-day trip undertaken and successfully accomplished by several dozen women hikers along with their male companions.[1]

Horseback Riding

Probably more typical for visitors to the park in the 1910s was seeing the park via horseback. We saw in Chapter 4 how Mary Roberts Rinehart and other women joined the 1915 Howard Eaton excursion around the park. Not all horse tours were of that duration (or fame), but women seeing the grandeur of Glacier Park from horseback was a common sight from the 1910s well into the early 1930s, after which auto visitation began to become the norm with the completion of Going-to-the-Sun Road in 1933.

Mountain Climber Dorothy Pilley

The Great Northern Railway used a variety of efforts to attract tourists to use their trains to, and the facilities in, Glacier National Park. In 1926, they sponsored British mountain climber Dorothy Pilley (also known as Pilley-Richards, having married Ivor Richards who accompanied her on the trip) to come to the park,

Three women and a tour wrangler having a snowball fight near Piegan Pass, from the same 1916 Great Northern Railway brochure as the previous photo. (*Unknown photographer, GNR*)

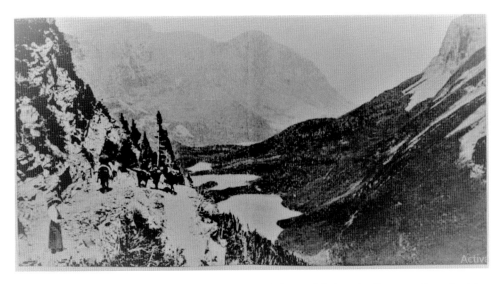

Tourists on the steep, switchback-laden section of the trail below Swiftcurrent Pass, looking down across Bullhead Lake. Note the woman on lower left in the long skirt, looking toward the photographer. Photo from the same 1916 Great Northern Railway brochure as in the previous two photos. (*Unknown photographer, GNR*)

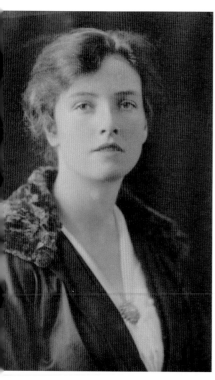

Left: Dorothy Pilley, *circa* 1922. A striking resemblance exists between the woman on the hiking brochure cover previously shown and this photograph. (*Wikipedia and Pilley Family Archives, photographer unknown*)

Below: Members of the Pinnacle Club, a women's climbing club based in the United Kingdom co-founded by Dorothy Pilley, *circa* late 1920s–early 1930s. Dorothy Pilley is standing, second from left. (*Wikipedia, photo from Dan Richards*)

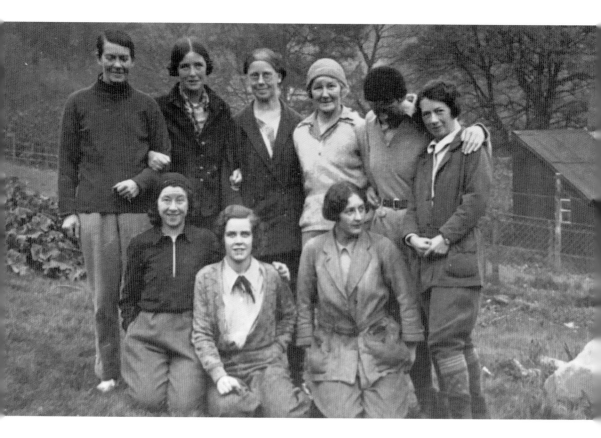

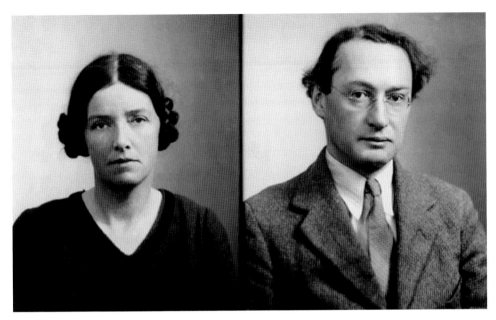

Above: Passport photos of Dorothy Pilley and her husband Ivor Richards. (*Photos undated, from Dan Richards and Pilley family archives*)

Below: Dorothy Pilley and Ivor Richards in an unspecified outdoor setting, *circa* mid-1920s. (*Photo undated, from ukclimbing.com and Pilley family archives*)

climb peaks, and write about mountain climbing for women in pamphlets published by the Great Northern. Pilley was a renowned European climber and early feminist who ardently supported the role of women as independent climbers not dependent on male climbing leaders.[2, 3]

Pilley and her husband Richards, along with German climber Hans Reiss, spent nineteen days in Glacier Park in the summer of 1926, during which time they climbed twenty-five peaks. Their efforts were documented in both photographs and in one silent film. Although some sources cite the photographer accompanying the climbers as Ray Bell, documented photos taken by famous Glacier Park photographer T. J. Hileman indicate that the latter was the group photographer. The unattributed commercially produced film, entitled *Crags and Crevasses*, was a silent, captioned Kodak Cinegraph.[4, 5]

Most of the activity photographically documented for the Pilley climbing party was based out of the Swiftcurrent valley and the now-razed Many Glacier chalets. Peaks climbed included Altyn Peak, the Ptarmigan Wall above the location where Ptarmigan Tunnel now exists, and Grinnell Point.

Dorothy Pilley checking out her backpack and equipment at the now-burned and razed Many Glacier chalets. (*Photo by Ray Bell, 1926, ukclimbing.com*)

Ivor Richards and Dorothy Pilley climbing Altyn Peak, with Swiftcurrent Lake and the Many Glacier Hotel far below. Dorothy Pilley's head appears near bottom, ascending up out of a rock chimney. (*Photo by T.J. Hileman, 1926; GNP Archives 27011*)

Above: Left, Ivor Richards and Dorothy Pilley climbing Altyn Peak, with Swiftcurrent and Josephine Lakes far below, 1926; *right,* a very young edition of the author on the summit of Altyn Peak with the same general scenery far below, June 1973. (*Left, photo by T.J. Hileman, GNP Archives 27013; right, author's personal collection, photo by Mike Butler*)

Left: Ivor Richards, Dorothy Pilley, and artist Hans Reiss climbing Grinnell Point, 1926. Swiftcurrent Lake and the Many Glacier Hotel are at lower right. (*Photo by T.J. Hileman, GLAC 26487*)

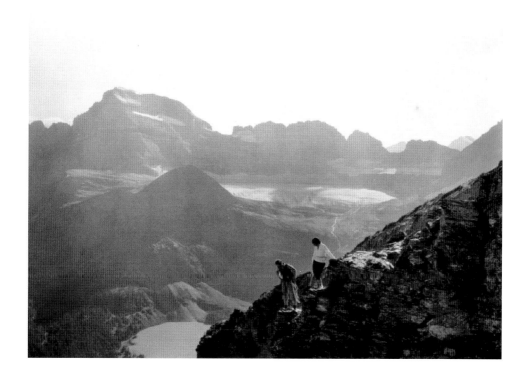

Above: Ivor Richards and Dorothy
Pilley on Grinnell Point, with Grinnell
Glacier directly behind them, 1926.
(*Photo by T.J. Hileman, GLAC 27007*)

Right: Dorothy Pilley, Ivor Richards,
and probably Han Reiss on top of the
Ptarmigan Wall, with Elizabeth Lake in
the Belly River valley far below, 1926.
(*T.J. Hileman photo, GLAC 26992*)

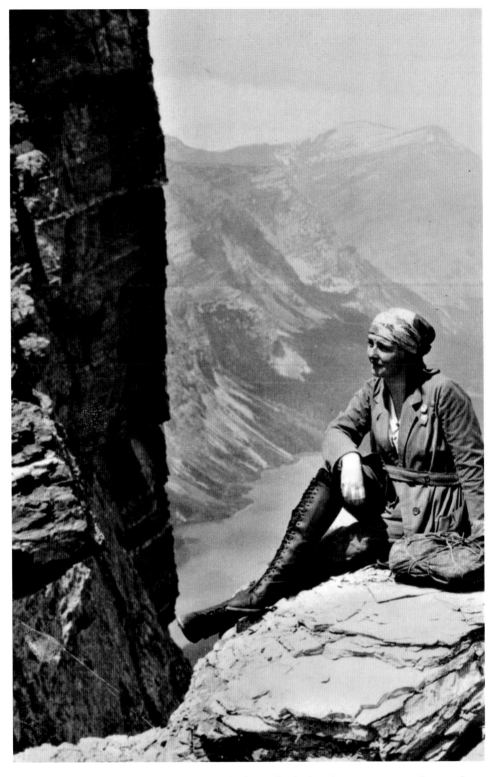

Dorothy Pilley on the Ptarmigan Wall, overlooking Elizabeth Lake, 1926. (*T.J. Hileman photo*, *GNP Archives*)

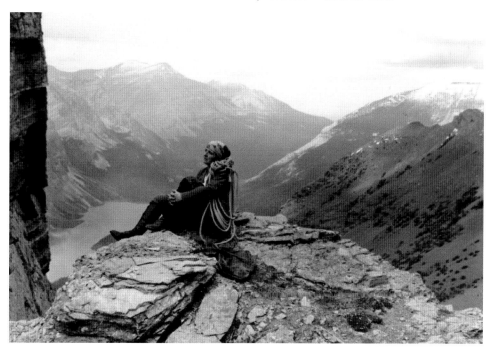

Above: A different pose by
Dorothy Pilley on the Ptarmigan
Wall overlooking Elizabeth Lake,
1926. (*T.J. Hileman photo, GLAC
26945*)

Right: Dorothy Pilley and Ivor
Richards scaling a wall to a
chimney in the Swiftcurrent
valley, 1926. (*Photo by T.J.
Hileman, GLAC 8231_Hileman
39-26*)

In addition to the climbs in the Many Glacier region, Pilley and Richards climbed Blackfoot Glacier and Peak, as documented both in photographs and in the aforementioned silent film. This setting allowed Pilley and Richards to climb vertical ice faces, traverse crevasses, and practice self-arresting with ice axes in descending steep ice faces.

After their 1926 climbs, Pilley wrote promotional pamphlets as "payback" for the sponsoring Great Northern Railway. In that writing, Pilley described proper equipment for both hiking and climbing in the park. Her writing also evoked a sense of wonder for climbing in the park, which is particularly interesting in that her autobiography, *Climbing Days*, devoted less than three of its 340 pages of text to Glacier National Park.[6,7]

Above left: Pilley and Richards on Blackfoot Glacier with ice axes, 1926. (*Photo by T.J. Hileman, GLAC 8230_Hileman RB-03*)

Above right: Pilley and Richards climbing an ice wall on Blackfoot Glacier, 1926. (*Photo by T.J. Hileman, GLAC 8230_Hileman RB-34*)

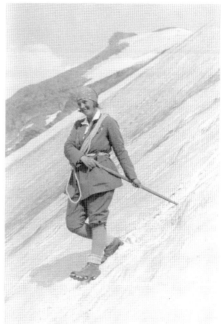

Above left: Dorothy Pilley on an icy cliff of Blackfoot Glacier using ice ax, 1926. (*Photo by T.J. Hileman, GLAC 8231_Hileman 35-26*)

Above right: Dorothy Pilley descending a glacier surface, probably Blackfoot Glacier, 1926. (*Photo by T.J. Hileman, GLAC 8231_Hileman 33-26*)

Below: A portion of an essay penned by Dorothy Pilley for a Great Northern Railway pamphlet aimed at inducing women to come visit Glacier Park, *circa* 1926. (*GNR, UMT elrod-2_b5a76679e5*)

Camping Party in Glacier National Park

Walking and Climbing in Glacier National Park

By Dorothy E. Pilley

Ladies' Alpine Club, England. Editor Pinnacle Club.

Club Swisse des Femmes Alpinistes.

Club Alpin Francais.

Glacier National Park, northwestern Montana, area, 1,534 square miles. Its southern boundary is Marias Pass, through which the Great Northern Railway crosses the crest of the Montana Rockies.

FOR women who want to try a new and original form of vacation, now is the time to plan an expedition to the Montana Rockies. From June until September are ideal months for climbing or hiking—when the rocks are dry and free from ice, when the snow is in good condition and when trees and flowers are at their loveliest. These, too, are the months of sunshine, when the stupendous, multi-colored walls and innumerable ridges become even richer toned as they curve down and away thousands of feet to the valleys. Perhaps at sunset this unique color quality of Glacier may be seen in all its glory, for then the great cirques are full of dull reds and yellows, amber and pale

green. Against the sky the upper heights are still flecked with gold, lit with that mellow glow of fading day, while in the valleys the flush has disappeared, evening has come quietly to the lakes, leaving them mysterious and serene.

It is for those who like nature in all her moods that the mountains call with an insistence which cannot be denied. At Glacier National Park they are easily accessible, offer every kind of opportunity, from easy trail walking to hard exploration of serrated ridges and steep aretes and are ideal as an introduction to the sport. And this pursuit is one which combines aesthetic emotion, intellectual delight and physical exhilaration in such complex, varying degrees that complete analysis is impossible.

Not only beauty, but the zest for conquest is a large factor in the joy of climbing. Anyone who has made a new ascent will realize the peculiar charm of treading where no one yet has trod; others will remember the thrill of adventure to be captured in exploring unknown ranges and the beginner will never forget the exquisite satisfaction of reaching her first summit. To them all has come the exhilaration of feeling the racing wind over open country; of seeing oblique rainstorms sweeping the hillside; of watching sunshine or shadow playing in the valleys and hearing the rushing streams in the half light of myriad stars. And in these things is inexpressible contentment.

To achieve such a sense of power and delight, good health is essential—any climber would confess to hours of disgust produced by ill-considered diet or excessive strain—indigestion, high altitudes (without preliminary training), a touch of the sun, have a violent effect on the physique of a climber—but any experienced person will guard against excesses and the novice with a little thought can avoid discomforts.

Mountain Equipment

Of primary importance is the equipment necessary in the mountains; it is slightly different for walking and climbing.

Walking

By this is implied ascending the mountains on well-marked trails. Proper foot-gear is the

Moonlight on Lake McDermott, Glacier National Park

most essential consideration. Without comfortable feet there can be no enjoyment. So many girls who spend most of the year in the city and are accustomed to pavements tend to retain their familiar shoes when on vacation. They say gayly, "That is what I always wear." But thin soled, high-heeled shoes and light hosiery are unsuitable for rough, steep trails. To start out thus shod, a tenderfoot, is to return with heels

Afterword:
The Lasting Legacy of the
Pioneering Women of Glacier Park

The pioneering women of Glacier National Park came from diverse backgrounds and locations. They illustrated the drive and fortitude to make a difference in an era during which women were often considered second-class citizens. Yet, unfortunately, the era of women needing to be pioneers did not end in 1940, the time period at which this book ends. The first actual female law-enforcement park ranger in Glacier Park (as opposed to a ranger naturalist) was not appointed until 1979. In the realm of park concessions, the first female jammer (driver of one of the iconic red buses of the park) was not hired until the early 1980s. Women working in the park on trail crew have been around since the 1980s, but they are still remarked upon as oddities by visitors that they encounter. The first woman superintendent of Glacier National Park, Suzanne Lewis, served in 2000 and 2001. The first woman hired as a mule packer and wrangler for delivering backcountry supplies was not hired until 2017. The need for pioneering women in Glacier National Park and elsewhere continues, and that, in itself, is a sad commentary on our society almost a quarter of a way through the twenty-first century.[1,2]

Endnotes

Introduction

 1 MacDonald, D. H. and Kinsner, J., Final Inventory & Evaluation Report Glacier National Park North Fork Homestead Archeological Project (Missoula, MT: University of Montana, p. 1.

Chapter 1

 1 Thompson, S., Kootenai Culture Committee, and Pikunni Traditional Association, People Before the Park: The Kootenai and Blackfeet Before Glacier National Park (Helena, MT: Montana Historical Society Press, 2015), pp. 7–18.
 2 Wikipedia, Sacagawea (en.wikipedia.org/wiki/Sacagawea, last accessed May 15, 2022)
 3 Holterman, J., Place Names of Glacier/Waterton National Parks (West Glacier, MT: Glacier Natural History Association, 1985), p. 21.
 4 Passmore, B., What They Called It: Stories of Glacier's Names Along Going-to-the-Sun Road (Kalispell, MT: Montana Outdoor Guidebooks LLC, 2014), p. 32.
 5 Schultz, J. W., Blackfeet Tales of Glacier National Park (Boston, MA: Houghton Mifflin Company, 1916), p. 12.
 6 Ibid.
 7 Hungry Wolf, A., The Good Medicine Book (New York, NY: Warner Paperback Library, 1973), p. 93.
 8 Holterman, op. cit., pp. 102, 113.
 9 Passmore, B., What They Called It: Volume II Glacier's Names from Many Glacier to Marias Pass (Kalispell, MT: Montana Outdoor Guidebooks LLC, 2016), pp. 61, 77.
10 Holterman, op. cit., p. 39.
11 Sanders, H. F., The White Quiver (New York: Duffield & Company, 1913), p. 8.
12 Cahill, C. D., "The Indian Princess Who Wasn't There: The Strange Case of Dawn Mist," Chapter 5 in Recasting the Vote: How Women of Color Transformed the Suffrage Movement (Chapel Hill, NC: The University of North Carolina Press, 2020), p. 72.
13 Ibid., p. 75.
14 Ibid., p. 75.

Chapter 2

 1 MacDonald and Kinsner, Final Inventory & Evaluation Report Glacier National Park
 North Fork Homestead Archeological Project, p. 14.
 2 National Park Service, McCarthy Homestead Cabin, National Register of Historic Places
 Nomination, Glacier National Park (West Glacier, MT: Glacier National Park, 1984), p. 1.
 3 MacDonald and Kinsner, op. cit., various pages.
 4 National Park Service, op. cit., p. 2.
 5 National Park Service, op. cit., p. 3.
 6 Crown of the Continent Research Learning Center, North Fork Homesteads Resource
 Brief (West Glacier, MT: Glacier National Park, 2014), p. 2.
 7 Harrington, L., History of Apgar (Apgar, MT: Apgar School and Teacher, Mrs. Leona
 Harrington, 1950), p. 40.
 8 National Park Service, Adair, W.L., General Mercantile Historic District Polebridge Store;
 Polebridge Mercantile (Washington, DC: National Register of Historic Places Inventory
 Nomination Form, 1985), pp. 2–3.
 9 Harrington, op. cit., various pages
 10 Fraley, J., Wild River Pioneers: Adventures in the Middle Fork of the Flathead, Great
 Bear Wilderness and Glacier National Park (Whitefish, MT: Big Mountain Publishing,
 2008), chapter 10.
 11 Harrington, op. cit., p. 34.
 12 Fraley, op. cit., p. 176.
 13 Harrington, op. cit., p. 34
 14 Fraley, op. cit., pp. 177–178.
 15 Harrington, op. cit., p. 12.
 16 Minetor, R., Historic Glacier National Park: The Stories Behind One of America's Great
 Treasures (Guilford, CT: Rowman and Littlefield, 2016), p. 88.
 17 Fraley, op. cit., p. 167.
 18 Green, C., Montana Memories Vol. IV (Great Falls, MT: Blue Print & Letter Co., 1972),
 p. 109.
 19 Fraley, op. cit., pp. 170–171.
 20 Fraley, op. cit., pp. 178–179.
 21 Green, op. cit., p. 109.
 22 Fraley, op. cit., various chapters.
 23 Fraley, J., A Woman's Way West: In and Around Glacier National Park from 1925 to
 1990 (Whitefish, MT: Big Mountain Publishing, 1998), various chapters.
 24 Lutz, F. W., Jr., Growing Up in Glacier Park (Kalispell, MT: Scott Company Publishing,
 2012), p. 116.
 25 Wettstein, B. L., Dream Chasers of the West: A Homestead Family of Glacier Park
 (Pateros, WA: Log Cabin Publishing, 2006), pp. 63, 106–107.
 26 Ibid., p. 281.

Chapter 3

 1 Devlin, V., "In a Man's World, Women Made Their Mark in Glacier National Park," The
 Missoulian (Missoula, MT: The Missoulian, October 29, 2014), numerous pages.
 2 National Park Service, National Park Service Uniforms Number 4: Breeches, Blouses,
 and Skirts 1918–1981 (Washington, DC: National Park Service, cr.nps.gov/history/
 online_books/workman4/vol4a.htm, 2020), numerous online pages.
 3 Gildart, R. C., Montana's Early-Day Rangers (Helena, MT: Montana Magazine, Inc.,
 1985), p. 79.
 4 Lee, L. (ed.), Backcountry Ranger: The Diaries & Photographs of Norton Pearl (Elk
 Rapids, MI: Leslie Lee, 1994), various pages.

5 Guthrie, C. W., The First Ranger: Adventures of a Pioneer Forest Ranger, Glacier Country 1902–1910 (Huson, MT: Redwing Publishing, 1995), p. 117.

6 Guthrie, C. W., First Rangers: The Life and Times of Frank Liebig and Fred Herrig, Glacier Country 1902–1910 (Helena, MT: Farcountry Press, 2019), p. 94.

7 Ibid., pp. 93–94.

8 Guthrie, 1995, op. cit., pp. 117–132.

9 Guthrie, 2019, op. cit., pp. 97–119.

10 Fraley, J., Wild River Pioneers: Adventures in the Middle Fork of the Flathead, Great Bear Wilderness and Glacier National Park (Whitefish, MT: Big Mountain Publishing, 2008), pp. 134–155.

11 Holterman, J., Who Was Who in Glacier Land (Kalispell, MT: Paper Chase Copy Center, 2001), pp. 79–80.

12 Fraley, op. cit., 2008, p. 138.

13 Fraley, J., "Bootleg Lady of Glacier Park," in Stanley, D. (ed.), The Glacier Park Reader (Salt Lake City, UT: The University of Utah Press, 2017), p. 199.

14 Holterman, op. cit., p. 79.

15 Fraley, op. cit., 2017, pp. 201–202.

16 Holterman, J., Place Names of Glacier/Waterton National Parks (West Glacier, MT: Glacier Natural History Association, 1985), pp. 41–42.

17 Fraley, op. cit., 2017, pp. 201–202.

18 Holterman, op. cit., p. 79.

19 Fraley, op. cit., 2008, p. 151.

20 Fraley, op. cit., 2017, pp. 203–204.

21 McKay, K. L., Trails of the Past: Historical Overview of the Flathead National Forest, Montana, 1800–1960 (Kalispell, MT: U.S. Forest Service, 1994), p. 256.

22 Buchholtz, C. W., Man in Glacier (West Glacier, MT: Glacier Natural History Association, 1976), various pages.

23 Gildart, op. cit., pp. 39–42.

24 Buchholtz, op. cit., p. 65.

25 Gildart, op. cit., pp. 39–41.

26 Geoghegan, H., Historic Structure Report: Old St. Mary Ranger District (West Glacier, MT: Glacier National Park, 1978), p. 4.

27 Gildart, op. cit., p. 41.

28 Fraley, J., A Woman's Way West: In and Around Glacier National Park from 1925 to 1990 (Whitefish, MT: Big Mountain Publishing, 1998), pp. 47–85.

29 Ibid., pp. 87–88.

30 Ibid., pp. 87–88, 91–92.

31 Ibid., pp. 92–93.

32 Ibid., pp. 1–9.

33 Ibid., pp. 100–101.

34 Fraley, op. cit., 2008, pp. 39–40.

35 Ibid, pp. 53–56.

36 Montana Historical Society, Land of Many Stories: The People & Histories of Glacier National Park (Helena, MT: Education Office, Montana Historical Society, no date), mhs.mt.gov/education/docs/Footlocker/GlacierFtLkrR5.pdf, p. 24.

37 Reece, M., "The First Native American Ranger," Flathead Living (Kalispell, MT: Flathead Beacon), various pages.

38 Green, C., Montana Memories Vol. IV (Great Falls, MT: Blue Print & Letter Co., 1972), pp. 27–28.

39 Reece, op. cit., no page numbers given.

40 Montana Historical Society, op. cit., p. 25.

41 Scoyen, E. T., Glacier National Park Annual Report, Fiscal Year 1933 (West Glacier, MT: Glacier National Park, 1933), p. 16.

42 Guthrie, C. W., Fagre, D., and Fagre, A., Death & Survival in Glacier National Park (Helena, MT: Farcountry Press, 2017), pp. 221–222.
43 Hufstetler, M., "The Lonesome Life in Glacier National Park: Kishenehn Ranger Station, 1910–1940," Montana, The Magazine of Western History, Vol. 60 No. 4 (Helena, MT: Montana Historical Society, 2010), p. 69.

Chapter 4

 1 Sanders, H. F., Trails Through Western Woods (New York, NY: The Alice Harriman Company, 1910), various pages.
 2 Sanders, H. F., "Letter from Helen Fitzgerald Sanders to John Muir, 1911 Feb. 7," (Online Archive of California, 1911), oac.cdlib.org/ark:/13030/kt9t1nf5tb/?order=2&brand=oac4, pp. 1–3.
 3 Rinehart, M. R., Through Glacier Park: Seeing America First with Howard Eaton (Boston, MA: Houghton Mifflin and Company, 1916), p. 3.
 4 Bristol, G., Glacier National Park: A Culmination of Giants (Reno, NV: University of Nevada Press, 2017), pp. 99–100.
 5 Cohn, J., Improbable Fiction: The Life of Mary Roberts Rinehart (Pittsburgh, PA: University of Pittsburgh Press, 1980), p. 95.
 6 Rinehart, M. R., Tenting To-night: A Chronical of Sport and Adventure in Glacier Park and the Cascade Mountains (Boston, MA: Houghton Mifflin Company, 1918), pp. 4–6, 11.
 7 Ibid., various pages.
 8 Great Northern Railway, Glacier National Park (St. Paul, MN: Great Northern Railway, undated), p. 3.
 9 Great Northern Railway, The Call of the Mountains: Vacations in Glacier National Park (St. Paul, MN: Great Northern Railway, 1925), p. 3
 10 Holtz, M. E. and Bemis, K. I., Glacier National Park: Its Trails and Treasures (New York, NY: George H. Doran Company, 1917), various pages.
 11 Butler, D. R., Early Photographers of Glacier National Park (Charleston, SC: America Through Time, 2022), various pages.
 12 Holtz and Bemis, op. cit., various pages.
 13 Ray, G., Grace Flandrau: Voice Interrupted (Roseville, MN: Edinborough Press, 2007), various pages.
 14 Laut, A. C., The Blazed Trail of the Old Frontier (New York, NY: Robert M. McBride & Company, 1926), pp. 265–266.
 15 Laut, A. C., Enchanted Trails of Glacier Park (New York, NY: Robert M. McBride & Company, 1926), various pages.
 16 Thompson, M., High Trails of Glacier National Park (Caldwell, ID: The Caxton Printers, Ltd., 1936), various pages.
 17 Ibid., various pages.
 18 Anonymous, "In Glacier Park," New York Times (New York, NY: New York Times, 1936), no page number.

Chapter 5

 1 Stauffer, J., Behind Every Man: The Story of Nancy Cooper Russell (Norman, OK: University of Oklahoma Press, 2008 edition, originally published in 1990), various pages.
 2 Russell, N. C. (ed. by T. A. Petrie and B. W. Dippie), Back-tracking in Memory: The Life of Charles M. Russell, Artist (Great Falls, MT: C.M. Russell Museum, 2021), various pages.
 3 Ibid.

4 Moravek, V., It Happened in Glacier National Park (Guilford, CT: The Globe Pequot Press, 2005), pp. 19–20.
5 Stauffer, op. cit., various pages.
6 Russell, op. cit., various pages.
7 Moravek, op. cit., pp. 20–21.
8 Ibid., pp. 21–22.
9 Dear, E. A. and Stanley, D., "Charlie Russell and Glacier Park," Montana, The Magazine of Western History, Vol. 63 No. 2 (Helena, MT: Montana Historical Society, 2013), p. 50.
10 Bottomly-O'looney, J., "Sitting Proud: The Indian Portraits of Joseph Scheuerle," Montana, The Magazine of Western History, Vol. 58 No. 3 (Helena, MT: Montana Historical Society, 2008), p. 65.
11 Boileau, T.I. and Boileau, M., "Joe Scheuerle: Modest Man with Friendly Palette," Montana, The Magazine of Western History, Vol. 21 No. 4 (Helena, MT: Montana Historical Society, 1971), pp. 41–42.
12 Ibid., p. 56.
13 Bottomly-O'looney, op. cit., p. 68.
14 Ibid., p. 69.
15 Boileau and Boileau, op. cit., p. 56.

Chapter 6

1 Peterson, L. L., The Call of the Mountains: The Artists of Glacier National Park (Tucson, AZ: Settlers West Galleries, 2002), pp. 31, 65, 143.
2 Ivy, T., Gillenwater, E., Kellogg, D., and Moss, E., A Timeless Legacy: Women Artists of Glacier National Park (Kalispell, MT: Hockaday Museum of Art, 2015), p. 4.
3 Ibid., pp. 27–28.
4 McGlynn, B. L. H., A Half-Century of Paintings by Elizabeth Lochrie, (doanehoag.com, lochrie.doanehoag.com/index_htm_files/Betty%20Hoag%20-Lochrie%20Bio.pdf, 1992), pp. 4–5.
5 Ivy et al., op. cit., p. 28.
6 Ibid., pp. 28–29.
7 McGlynn, op. cit., pp. 7–8.
8 Ivy et al., op. cit., p. 31.
9 Ibid., pp. 32–34.

Chapter 7

1 Parsons, M. R., "The Glacier National Park Outing," The Mountaineer, Vol. 7 (Seattle, WA: The Mountaineers, Inc., 1914), pp. 17–42.
2 Pilley, D., Climbing Days (London, U.K.: The Hogarth Press, 1989 reprint of 1935 original), p. 131.
3 Smith, A. K., Manless Climbing: Dorothy Pilley Richards 1894–1986, akennedysmith.com/2021/01/30/manless-climbing-dorothy-pilley-richards-1894-1986/ (2021, online pages).
4 Glacier National Park, Dorothy Pilley in Glacier National Park (West Glacier, MT: Glacier National Park, 2019), glaciernps.tumblr.com/post/186380878337/dorothy-pilley-in-glacier-national-park-in-1926, one online page.
5 Watson, D., 16mm Movie Extras, (Seattle, WA: The Mountaineers History Committee, 2019), alpenglow.org/mountaineers-history/notes/movie/dw-16mm-extras.html, online film.
6 Pilley, D., Walking and Climbing in Glacier National Park (St. Paul, MN: Great Northern Railway, undated), entire document.
7 Pilley, 1935, op. cit., pp. 297–299.

Afterword

1 Byl, C., Dirt Work: An Education in the Woods (Boston, MA: Beacon Press, 2013), numerous pages.
2 Scott, T., "Meet Glacier National Park's First Female Packer," Flathead Beacon (Kalispell, MT., Flathead Beacon, 2017), online p. 1.